Herbert Allen Giles

Chinese Sketches

The Institutions of a despised people cannot be judged with fairness

Herbert Allen Giles

Chinese Sketches
The Institutions of a despised people cannot be judged with fairness

ISBN/EAN: 9783337004026

Printed in Europe, USA, Canada, Australia, Japan

Cover: Foto ©Paul-Georg Meister /pixelio.de

More available books at **www.hansebooks.com**

CHINESE SKETCHES.

BY

HERBERT A. GILES,

OF H.B.M.'S CHINA CONSULAR SERVICE.

"The institutions of a despised people cannot be judged with fairness."
Spencer's Sociology : The Bias of Patriotism.

LONDON:

TRÜBNER & CO., LUDGATE HILL.

SHANGHAI: KELLY & CO.

1876.

PREFACE.

THE following *Sketches* owe their existence chiefly to frequent peregrinations in Chinese cities, with pencil and note-book in hand. Some of them were written for my friend Mr F. H. Balfour of Shanghai, and by him published in the columns of the *Celestial Empire*. These have been revised and partly re-written; others appear now for the first time.

It seems to be generally believed that the Chinese, as a nation, are an immoral, degraded race; that they are utterly dishonest, cruel, and in every way depraved; that opium, a more terrible scourge than gin, is now working frightful ravages in their midst; and that only the forcible diffusion of Christianity can save the Empire from speedy and overwhelming ruin. An experience of eight years has taught me that, with all their faults, the Chinese are a hardworking, sober, and happy people, occupying an intermediate place between the wealth and culture, the vice and misery of the West.

<div style="text-align:right">H. A. G.</div>

SUTTON, SURREY, 1st *November* 1875.

CHINESE SKETCHES.

THE DEATH OF AN EMPEROR.

His Imperial Majesty, Tsai-Shun, deputed by Heaven to reign over all within the four seas, expired on the evening of Tuesday the 13th January 1875, aged eighteen years and nine months. He was erroneously known to foreigners as the Emperor T'ung Chih ; but T'ung Chih was merely the style of his reign, adopted in order that the people should not profane by vulgar utterance a name they are not even permitted to write.* Until the new monarch, the late Emperor's cousin, had been duly installed, no word of what had taken place was breathed beyond the walls of the palace ; for dangerous thoughts might have arisen had it been known that the State was drifting rud-

* Either one or all of the characters composing an emperor's name are altered by the addition or omission of certain component parts ; as if, for instance, we were to write an Albart chain merely because Albert is the name of the heir-apparent. Similarly, a child will never utter or write its father's name ; and the names of Confucius and Mencius are forbidden to all alike.

A

derless, a prey to the wild waves of sedition and law-
less outbreak. The accession of a child to reign
under the style of Kuang Hsü was proclaimed before
it was publicly made known that his predecessor had
passed away.

Of the personal history of the ill-fated boy who has
thus been prematurely cut off just as he was entering
upon manhood and the actual government of four
hundred million souls, we know next to nothing. His
accession as an infant to the dignities of a sensual,
dissipated father, attracted but little attention either
in China or elsewhere; and from that date up to the
year 1872, all we heard about His Majesty was, that
he was making good progress in Manchu, or had hit
the target three times out of ten shots at a distance of
about twenty-five yards. He was taught to ride on
horseback, though up to the day of his death he never
took part in any great hunting expeditions, such as
were frequently indulged in by earlier emperors of
the present dynasty. He learnt to read and write
Chinese, though what progress he had made in the
study of the Classics was of course only known to his
teachers. Painting may or may not have been an
Imperial hobby; but it is quite certain that the drama
received more perhaps than its full share of patronage.
The ladies and eunuchs of the palace are notoriously
fond of whiling away much of their monotonous
existence in watching the grave antics of professional
tragedians and laughing at the broad jokes of the low-
comedy man, with his comic voice and funnily-painted

face. Listening to the tunes prescribed by the Book of Ceremonies, and dining in solemn solitary grandeur off the eight * precious kinds of food set apart for the sovereign, his late Majesty passed his boyhood, until in 1872 he married the fair A-lu-te, and practically ascended the dragon throne of his ancestors. Up to that time the Empresses-Dowager, hidden behind a bamboo screen, had transacted business with the members of the Privy Council, signing all documents of State with the vermilion pencil for and on behalf of the young Emperor, but probably without even going through the formality of asking his assent. The marriage of the Emperor of China seemed to wake people up from their normal apathy, so that for a few months European eyes were actually directed towards the Flowery Land, and the *Illustrated London News*, with praiseworthy zeal, sent out a special correspondent, whose valuable contributions to that journal will be a record for ever. The ceremony, however, was hardly over before a bitter drop rose in the Imperial cup. Barbarians from beyond the sea came forward to claim the right of personal interview with the sovereign of all under Heaven. The story of the first audience is still fresh in our memories; the trivial difficulties introduced by obstructive statesmen at every stage of the proceedings, questions of etiquette and precedence raised at every turn, until finally the *kotow* was triumphantly rejected and five

* These are—bears' paws, deers' tail, ducks' tongues, torpedos' roe, camels' hump, monkeys' lips, carps' tails, and beef-marrow.

bows substituted in its stead. Every one saw the curt paragraph in the *Peking Gazette,* which notified that on such a day and at such an hour the foreign envoys had been admitted to an interview with the Emperor. We all laughed over the silly story so sedulously spread by the Chinese to every corner of the Empire, that our Minister's knees had knocked together from terror when Phaeton-like he had obtained his dangerous request; that he fell down flat in the very presence, breaking all over into a profuse perspiration, and that the haughty prince who had acted as his conductor chid him for his want of courage, bestowing upon him the contemptuous nickname of "chicken-feather."

Subsequently, in the spring of 1874, the late Emperor made his great pilgrimage to worship at the tombs of his ancestors. He had previous to his marriage performed this filial duty once, but the mausoleum containing his father's bones was not then completed, and the whole thing was conducted in a private, unostentatious manner. But on the last occasion great preparations were made and vast sums spent (on paper), that nothing might be wanting to render the spectacle as imposing as money could make it. Royalty was to be seen humbly performing the same hallowed rites which are demanded of every child, and which can under no circumstances be delegated to any other person as long as there is a son or a daughter living. The route along which His Majesty was to proceed was lined with closely-packed crowds

of loyal subjects, eager to set eyes for once in their lives upon a being they are taught to regard as the incarnation of divinity ; and when the Sacred Person really burst upon their view, the excitement was beyond description. ˙Young and old, women and children, fell simultaneously upon their knees, and tears and sobs mingled with the blessings showered upon His Majesty by thousands of his simple-minded, affectionate people. •

The next epoch in the life of this youthful monarch occurred a few months ago. The Son of Heaven * had not availed himself of western science to secure immunity from the most loathsome in the long category of diseases. He had not been vaccinated, in spite of the known prevalence of smallpox at Peking during the winter season. True, it is but a mild form of smallpox that is there common ; but it is easy to imagine what a powerless victim was found in the person of a young prince enervated by perpetual cooping in the heart of a city, rarely permitted to leave the palace, and then only in a sedan-chair, called out of his bed at three o'clock every morning summer or winter, to transact business that must have had few charms for a boy, and possessed of no other means of amusement than such as he could derive from the society of his wife or concubines. Occasional bulletins announced that the disease was progressing favourably, and latterly it was signified

* Such terms as " Brother of the Sun and Moon " are altogether imaginary, and are quite unknown in China.

that His Majesty was rapidly approaching a state of convalescence. His death, therefore, came both suddenly and unexpectedly; happily, at a time when China was unfettered by war or rebellion, and when all the energies of her statesmen could be employed in averting either one catastrophe or the other. For one hundred days the Court went into deep mourning, wearing capes of white fur with the hair outside over long white garments of various stuffs, lined also with white fur, but of a lighter kind than that of the capes. Mandarins of high rank use the skin of the white fox for the latter, but the ordinary official is content with the curly fleece of the snow-white Mongolian sheep. For one hundred days no male in the Empire might have his head shaved, and women were supposed to eschew for the same period all those gaudy head ornaments of which they are so inordinately fond. At the expiration of this time the Court mourning was changed to black, which colour, or at any rate something sombre, will be worn till the close of the year.

For twelve long months there may be no marrying or giving in marriage, that is among the official classes; the people are let off more easily, one hundred days being fixed upon as their limit. For a whole year it is illegal to renew the scrolls of red paper pasted on every door-post and inscribed with cherished maxims from the sacred books; except again for non-officials, whose penance is once more cut down to one hundred days' duration. In these sad times the birth of a son—a

Chinaman's dearest wish on earth—elicits no congratulations from thronging friends ; no red eggs are sent to the lucky parents, and no joyous feast is provided in return. Merrymaking of all kinds is forbidden to all classes for the full term of one year, and the familiar sound of the flute and the guitar is hushed in every household and in every street.* The ordinary Chinese visiting-card—a piece of red paper about six inches by three, inscribed with its owner's name in large characters—changes to a dusky brown ; and the very lines on letter paper, usually red, are printed of a dingy blue. Official seals are also universally stamped in blue instead of the vermilion or mauve otherwise used according to the rank of the holder. Red is absolutely tabooed ; it is the emblem of mirth and joy, and the colour of every Chinese maiden's wedding dress. It is an insult to write a letter to a friend or stranger on a piece of plain white paper with black ink. Etiquette requires that the columns should be divided by red lines ; or, if not, that a tiny slip of red paper be pasted on in recognition of the form. For this reason it is that all stamps and seals in China are *red*—to enable tradesmen, officials, and others to use any kind of paper, whether it has already some red about it or not ; and every foreigner in China would do well to exact on all occasions the same formalities from his employés as they would consider a matter of duty towards one of their own countrymen, however low he might be in the social scale.

* Mencius. Book v., part ii., ch. 4.

Certain classes of the people will suffer from the observance of these ceremonies far more severely than others. The peasant may not have his head shaved for one hundred days—inconvenient, no doubt, for him, but mild as compared with the fate of thousands of barbers who for three whole months will not know where to look to gain their daily rice. Yet there is a large section of the community much worse off than the barbers, and this comprises everybody connected in any way with the theatres. Their occupation is gone. For the space of one year neither public or private performance is permitted. During that time actors are outcasts upon the face of the earth, and have no regular means of getting a livelihood. The lessees of theatres have most likely feathered their own nests sufficiently well to enable them to last out the prescribed term without serious inconvenience ; but with us, actors are proverbially improvident, and even in frugal China they are no exception to the rule.

Officials in the provinces, besides conforming to the above customs in every detail, are further obliged on receipt of the " sad announcement " to mourn three times a-day for three days in a particular chapel devoted to that purpose. There they are supposed to call to mind the virtues of their late master, and more especially that act of grace which elevated each to the position he enjoys. Actual tears are expected as a slight return for the seal of office which has enabled its possessor to grow rich at the expense too often of

a poor and struggling population. We fancy, however, that the mind of the mourner is more frequently occupied with thinking how many friends he can count among the Imperial censors than in dwelling upon the transcendent bounty of the deceased Emperor.

We sympathise with the bereaved mother who has lost her only child and the hope of China ; but on the other hand if there is little room for congratulation, there is still less for regret. The nation has been deprived of its nominal head, a vapid youth of nineteen, who was content to lie *perdu* in his harem without making an effort to do a little governing on his own responsibility. During the ten years that foreigners have resided within half a mile of his own apartments in the palace at Peking, he has either betrayed no curiosity to learn anything at all about them, or has been wanting in resolution to carry out such a scheme as we can well imagine would have been devised by some of his bolder and more vigorous ancestors. And now once more the sceptre has passed into the hands of a child who will grow up, like the late Emperor, amid the intrigues of a Court composed of women and eunuchs, utterly unfit for anything like energetic government.

The splendid tomb which has been for the last twelve years in preparation to receive the Imperial coffin, but which, according to Chinese custom, may not be completed until death has actually taken place,

will witness the last scene in the career of an unfortunate young man who could never have been an object of envy even to the meanest of his people, and who has not left one single monument behind him by which he will be remembered hereafter.

It is, perhaps, tolerably safe to say that the position of women among the·Chinese is very generally misunderstood. In the squalid huts of the poor, they are represented as ill-used drudges, drawers of water and grinders of corn, early to rise and late to bed, their path through the vale of tears uncheered by a single ray of happiness or hope, and too often embittered by terrible pangs of starvation and cold. This picture is unfortunately true in the main; at any rate, there is sufficient truth about it to account for the element of sentimental fiction escaping unnoticed, and thus it comes to be regarded as an axiom that the Chinese woman is low, very low, in the scale of humanity and civilisation. The women of the poorer classes in China have to work hard indeed for the bowl of rice and cabbage which forms their daily food, but not more so than women of their own station in other countries where the necessaries of life are dearer, children more numerous, and a drunken husband rather the rule than the exception. Now the working classes in China are singularly sober; opium is beyond their means, and few are addicted to the use of Chinese wine. Both men and women smoke,

and enjoy their pipe of tobacco in the intervals of work; but this seems to be almost their only luxury. Hence it follows that every cash earned either by the man or woman goes towards procuring food and clothes instead of enriching the keepers of grog-shops: besides which the percentage of quarrels and fights is thus very materially lessened. A great drag on the poor in China is the family tie, involving as it does not only the support of aged parents, but a supply of rice to uncles, brothers, and cousins of remote degrees of relationship, during such time as these may be out of work. Of course such a system cuts both ways, as the time may come when the said relatives supply, in their turn, the daily meal; and the support of parents in a land where poor-rates are unknown, has tended to place the present high premium on male offspring. Thus, though there is a great deal of poverty in China, there is very little absolute destitution, and the few wretched outcasts one does see in every Chinese town, are almost invariably the once opulent victims of the opium-pipe or the gaming-table. The relative number of human beings who suffer from cold and hunger in China is far smaller than in England, and in this all-important respect, the women of the working classes are far better off than their European sisters. Wife-beating is unknown, though power of life and death is, under certain circumstances, vested in the husband (Penal Code, § 293); while, on the other hand, a wife may be punished with a hundred blows for merely striking her husband, who is also entitled to a divorce

(Penal Code, § 315). The truth is, that these poor women are, on the whole, very well treated by their husbands, whom they not unfrequently rule with as harsh a tongue as that of any western shrew.

In the fanciful houses of the rich, the Chinese woman is regarded with even more sympathy by foreigners generally than is accorded to her humbler fellow-countrywomen. She is represented as a mere ornament, or a soulless, listless machine—something on which the sensual eye of her opium-smoking lord may rest with pleasure while she prepares the fumes which will waft him to another hour or so of tipsy forgetfulness. She knows nothing, she is taught nothing, never leaves the house, never sees friends, or hears the news; she is, consequently, devoid of the slightest intellectual effort, and no more a companion to her husband than the stone dog at his front gate. Now, although we do not profess much personal acquaintance with the *gynécée* of any wealthy Chinese establishment, we think we have gathered quite enough from reading and conversation to justify us in regarding the Chinese lady from an entirely different point of view. In novels, for instance, the heroine is always highly educated—composes finished verses, and quotes from Confucius; and it is only fair to suppose that such characters are not purely and wholly ideal. Besides, most young Chinese girls, whose parents are well off, are taught to read, though it is true that many content themselves with being able to read and write a few hundred words. They all learn and excel

in embroidery; the little knick-knacks which hang at every Chinaman's waist-band being almost always the work of his wife or sister. Visiting between Chinese ladies is of everyday occurrence, and on certain fête-days the temples are crowded to overflowing with " golden lilies " * of all shapes and sizes. They give little dinner-parties to their female relatives and friends, at which they talk scandal, and brew mischief to their hearts' content. The first wife sometimes quarrels with the second, and between them they make the house uncomfortably hot for the unfortunate husband. " Don't you foreigners also dread the denizens of the inner apartments ? " said a hen-pecked Chinaman one day to us—and we think he was consoled to hear that viragos are by no means confined to China. One of the happiest moments a Chinese woman knows, is when the family circle gathers round husband, brother, or it may be son, and listens with rapt attention and wondering credulity to a favourite chapter from the " Dream of the Red Chamber." She believes it every word, and wanders about these realms of fiction with as much confidence as was ever placed by western child in the marvellous stories of the " Arabian Nights."

* A poetical name for the small feet of Chinese women.

IF there is one thing more than another, after the possession of the thirteen classics, on which the Chinese specially pride themselves, it is *politeness*. Even had their literature alone not sufficed to place them far higher in the scale of mental cultivation than the unlettered barbarian, a knowledge of those important forms and ceremonies which regulate daily intercourse between man and man, unknown of course to inhabitants of the outside nations, would have amply justified the graceful and polished Celestial in arrogating to himself the proud position he now occupies with so much satisfaction to himself. A few inquiring natives ask if foreigners have any notion at all of etiquette, and are always surprised in proportion to their ignorance to hear that our ideas of ceremony are fully as clumsy and complicated as their own. It must be well understood that we speak chiefly of the educated classes, and not of " boys " and compradores who learn in a very short time both to touch their caps and wipe their noses on their masters' pocket-handkerchiefs. Our observations will be confined to members of that vast body of men who pore day and night over the "Doctrine of the Mean,"

and whose lips would scorn to utter the language of birds.

And truly if national greatness may be gauged by the mien and carriage of its people, China is without doubt entitled to a high place among the children of men. An official in full costume is a most imposing figure, and carries himself with great dignity and self-possession, albeit he is some four or five inches shorter than an average Englishman. In this respect he owes much to his long dress, which, by the way, we hope in course of time to see modified; but more to a close and patient study of an art now almost monopolised in Europe by aspirants to the triumphs of the stage. There is not a single awkward movement as the Chinese gentleman bows you into his house, or supplies you from his own hand with the cup of tea so necessary, as we shall show, to the harmony of the meeting. Not until his guest is seated will the host venture to take up his position on the right hand of the former; and even if in the course of an excited conversation, either should raise himself, however slightly, from a sitting posture, it will be the bounden duty of the other to do so too. No gentleman would sit while his equal stood. Occasionally, where it is not intended to be over-respectful to a visitor, a servant will bring in the tea, one cup in each hand. Then standing before his master and guest, he will cross his arms, serving the latter who is at his right hand with the left hand, his master with the right. The object of this is to expose the palm—in Chinese,

the *heart*—of either hand to each recipient of tea. It is a token of fidelity and respect. The tea itself is called "guest tea," and *is not intended for drinking.* It has a more useful mission than that of allaying thirst. Alas for the red-haired barbarian who greedily drinks off his cupful before ten words have been exchanged, and confirms the unfavourable opinion his host already entertains of the manners and customs of the West! And yet a little trouble spent in learning the quaint ceremonies of the Chinese would have gained him much esteem as an enlightened and tolerant man. For while despising us outwardly, the Chinese know well enough that inwardly we despise them, and thus it comes to pass that a voluntary concession on our part to any of their harmless prejudices is always gratefully acknowledged. To return, "guest tea" is provided to be used as a signal by either party that the interview is at an end. A guest no sooner raises the cup to his lips than a dozen voices shout to his chair-coolies; so, too, when the master of the house is prevented by other engagements from playing any longer the part of host. Without previous warning—unusual except among intimate acquaintances—this tea should never be touched except as a signal of departure.

Strangers meeting may freely ask each other their names, provinces, and even prospects; it is not so usual as is generally supposed to inquire a person's age. It is always a compliment to an old man, who is justly proud of his years, and takes the curious form of

"your venerable teeth?" but middle-aged men do not as a rule care about the question, and their answers can rarely be depended upon. A man may be asked the number and sex of his children; also if his father and mother are still "in the hall," *i.e.*, alive. His wife, however, should never be alluded to even in the most indirect manner. Friends meeting, either or both being in sedan-chairs, stop their bearers at once, and get out with all possible expedition; the same rule applies to acquaintances meeting on horseback. Spectacles must always be removed before addressing even the humblest individual—sheer ignorance of which most important custom has often, we imagine, led to rudeness from natives towards foreigners, where otherwise extreme courtesy would have been shown. In such cases a foreigner must yield, or take the chances of being snubbed; and where neither self-respect or national dignity is compromised, we recommend him by all means to adopt the most conciliatory course. Chinese etiquette is a wide field for the student, and one which, we think, would well repay extensive and methodical exploration.

THE disadvantages of ignoring alike the language and customs of the Chinese are daily and hourly exemplified in the unsatisfactory relations which exist as a rule between master and servant. That the latter almost invariably despise their foreign patrons, and are only tempted to serve under them by the remunerative nature of the employment, is a fact too well known to be contradicted, though why this should be so is a question which effectually puzzles many who are conscious of treating their native dependants only with extreme kindness and consideration. The answer, however, is not difficult for those who possess the merest insight into the workings of the Chinese mind ; for just as every inhabitant of the eighteen provinces believes China to be the centre of civilisation and power, so does he infer that his language and customs are the only ones worthy of attention from native and barbarian alike. The very antagonism of the few foreign manners and habits he is obliged by his position to cultivate, tend rather to confirm him in his own sense of superiority than otherwise. For who but a barbarian would defile the banquet hour "when the wine mantles in the cups" with a *white* table-

cloth, the badge of grief and death? How much more elegant the soft *red* lacquer of the "eight fairy" table, with all its associations of the bridal hour! The host, too, at the *head* of his own board, sitting in what should be the seat of the most honoured guest, and putting the latter on his *right* instead of his left hand! Truly these red-haired barbarians are the very scum of the earth.

By the time he has arrived at this conclusion our native domestic has by a direct process of reasoning settled in his mind another important point, namely, that any practice of the civilities and ceremonies which Chinese custom exacts from the servant to the master, would be entirely out of place in reference to the degraded being whom an accidental command of dollars has invested with the title, though hardly with the rights, of a patron. Consequently, little acts of gross rudeness, unperceived of course by the foreigner, characterise the everyday intercourse of master and servant in China. The house-boy presents himself for orders, and even waits at table, in short clothes—an insult no Chinaman would dare to offer to one of his own countrymen. He meets his master with his tail tied round his head, and passes him in the street without touching his hat, that is, without standing still at the side of the street until his master has passed. He lolls about and scratches his head when receiving instructions, instead of standing in a respectful attitude with his hands at his side in a state of rest; enters a room with his shoes down at heel, or without

socks; omits to rise at the approach of his master, mistress, or their friends, and commits numerous other petty breaches of decorum which would ensure his instant dismissal from the house of a Chinese gentleman. We ourselves take a pride in making our servants treat us with the same degree of outward respect they would show towards native masters, and we believe that by strictly adhering to this system we succeed in gaining, to some extent, their esteem. Inasmuch, however, as foreign susceptibilities are easily shocked on certain points ignored by Chinamen of no matter what social standing, we have found it necessary to introduce a special Bill, known in our domestic circle as the Expectoration Act. Now it is a trite observation that the Chinese make capital soldiers if they are well commanded, and what is the head of a large business establishment but the commander-in-chief of a small army? The efficiency of his force depends far more upon the moral agencies brought to bear than upon any system of rewards and punishments human ingenuity can devise; for Chinamen, like other mortals, love to have their prejudices respected, and fear of shame and dread of ridicule are as deeply ingrained in their natures as in those of any nation under the sun. They have a horror of blows, not so much from the pain inflicted, as from the sense of injury done to something more elevated than their mere corporeal frames; and a friend of ours once lost a good servant by merely, in a hasty fit, *throwing his sock at him.* We therefore think that,

considering the vast extent of the Chinese empire and its innumerable population, all of whom are constructed mentally more or less on the same model, their language and customs are deserving of more attention than is generally paid to them by foreigners in China.

IT is an almost universally-received creed that behind the suicidal prejudices and laughable superstitions of the Chinese there is a mysterious fund of solid learning hidden away in the uttermost recesses—far beyond the ken of occidentals—of that *terra incognita*, Chinese literature. Sinologues darkly hint at elaborate treatises on the various sciences, impartial histories and candid biographies, laying at the same time extraordinary stress on the extreme difficulty of the language in which they are written, and carefully mentioning the number (sometimes fabulous) of the volumes of which each is composed. Hence, probably, it results that few students venture to push their reading beyond novels, and remain during the whole of their career in a state of darkness as to that literary wealth of China which enthusiasts delight to compare with her unexplored mines of metal and coal. Inasmuch, however, as it is not absolutely necessary to read a book from beginning to end to be able to form a pretty correct judgment as to its value, so, many students who are sufficiently advanced to read a novel with ease and without the help of a teacher, might readily gain an insight into a large enough number of the

most celebrated scientific or historical works to enable
them to comprehend the true worth of the whole of
this vast literature. For vast it undoubtedly is,
though our own humble efforts to appraise it justly,
in comparison of course with the other literatures of
the world, brought upon us in the first hours of dis-
covery the mortifying conviction that some years of
assiduous toil had been positively thrown away. Sir
W. Hamilton, if we recollect rightly, said that by so
many more languages as a man knows, by so many
more times is he a man—an apophthegm of but a
shallow kind if all he meant to convey was that an
Englishman who can speak French is also a French-
man by virtue of his knowledge of the colloquial.
The opening up of new fields of thought through the
medium of a new literature, is a result more worthy
the effort of acquiring a foreign language than spark-
ling in a *salon* with the purest imaginable accent; and
herein Sir W. Hamilton counted without Chinese.
The greater portion of the " Classics," cherished tomes
to which China thinks even now she owes her intel-
lectual supremacy over the rest of the world, is open
through Dr Legge's translation to all Englishmen, and
those who run may read, weighing it in the balance
and determining its status among the ethical systems
either of the past or present. Had we found as much
that is solid in other departments of Chinese literature,
as there is mixed up with the occasional nonsense and
obscurity of the Four Books, our protest would have
taken a milder form ; as it is, we think it right to

condemn any and all random assertions which tend to strengthen in the minds of those who have no opportunity of judging, the belief that China is possessed of a vast and valuable literature, in which, for aught any one knows to the contrary, there may lie buried gems of purest ray serene. Can it be supposed that, if true, nothing of all this has yet been brought to light ? There have been, and are now, foreigners possessing a much wider knowledge of Chinese literature than many natives of education, but, strange to say, such translations as have hitherto been given to the world have been chiefly confined to plays and novels ! We hold that all those whom tastes or circumstances have led to acquire a knowledge of the Chinese language have a great duty to perform, and this is to contribute each something to the scanty quota of translations from Chinese now existing. Let us see what the poets, historians, and especially the scientific men of China have produced to justify so many in speaking as they have done, and still do speak, of her bulky literature. Many, we think, will be deterred by the grave nonsense or childish superstitions which they dare not submit to foreign judges as the result of their labours in this fantastic field ; but to withhold such is to leave the public where it was before, at the mercy of unscrupulous or crazed enthusiasts.

We were led into this train of thought by an article in the *North China Daily News* of 10th July 1874, in which the writer speaks of China as " a luxuriant

mental oasis amidst the sterility of Eastern Asia," and "possessing a literature in vastness and antiquarian value surpassed by no other." He goes on to say that the translations hitherto made "have conveyed to us a faint notion of the compass, variety, solidity, and linguistic beauties of that literature." Such statements as these admit, unfortunately, of rhetorical support, sufficient to convince outsiders that at any rate there are two sides to the question, a conviction which could only be effectually dispelled by placing before them a few thousand volumes translated into English, and chosen by the writer of the article himself.* When, however, our enthusiast deals with more realisable facts, and says that in China "there is no organised book trade, nor publishers' circulars, nor Quaritch's Catalogues, nor any other catalogues whether of old or new books for sale," we can assure him he knows nothing at all about the matter ; that there is now lying on our table a very comprehensive list of new editions of standard works lately published at a large book-shop in Wu-chang Fu, with the price of each work attached ; and that Mr Wylie, in his "Notes on Chinese Literature," devotes five entire pages to the enumeration of some thirty well-known and voluminous catalogues of ancient and modern works.

* Baron Johannes von Gumpach. Died at Shanghai, 31st July 1875.

A RAMBLE through a native town in China must often have discovered to the observant foreigner small collections of second-hand books and pamphlets displayed on some umbrella-shaded stall, or arranged less pretentiously on the door-step of a temple. If innocent of all claims to a knowledge of the written language, he may take them for cheap editions of Confucius, with which literary chair-coolies are wont to solace their leisure hours ; at the worst, some of those myriad novels of which he has heard so much, and read—in translations—so little. It possibly never enters our barbarian's head that many of these itinerant booksellers are vendors of educational works, much after the style of Pinnock's Catechisms and other such guides to knowledge. Buying a handful the other day for a few cash,* we were much amused at the nature of the subjects therein discussed, and the manner in which they were treated. The first we opened was on Ethnology and Zoology, and gave an account of the wonderful types of men and beasts which exist in far-off regions beyond the pale of China and civilisation. There was the long-legged nation, the people

* About 24 cash go to a penny.

of which have legs three *chang* (thirty feet) long to
support bodies of no more than ordinary size, followed
by a short account of a cross-legged race, a term which
explains itself. We are next told of a country where
all the inhabitants have a large round hole right
through the middle of their bodies, the officials and
wealthy citizens being easily and comfortably carried
à la sedan-chair by means of a strong bamboo pole
passed through it. Then there is the feathered or
bird nation, the pictures of which people remind us
very much of Lapps and Greenlanders. A few lines
are devoted to a pygmy race of nine-inch men, also to
a people who walk with their bodies at an angle of 45°.
There is the one-armed nation, and a three-headed
nation, besides fish-bodied and bird-headed represen-
tatives of humanity; last but not least we have a race
of beings without heads at all, their mouth, eyes, nose,
&c., occupying their chests and pit of the stomach !

> " And of the cannibals that each other eat,
> The Anthropophagi, and men whose heads
> Do grow beneath their shoulders."

The little work which contains the above valuable
information was published in 1783, and has conse-
quently been nearly one hundred years before an en-
lightened and approving public.

Not to dwell upon the remaining portion, devoted
to Zoology, and containing wonderful specimens of
various kinds of animals and birds met with by
travellers beyond the Four Seas, we would remark
that the geography of the world, notwithstanding

some very fair existing treatises, is little studied by Chinese at the present day. More works on topography have been written in Chinese than in probably any other language, but to say that even these are read is quite another matter. Geography, properly so called, is almost entirely neglected, and in a rather extensive circle of literary acquaintances, it has never been our fortune to meet with a single scholar acquainted with the useful publications of Catholic or Protestant missionaries—the latter have not contributed much—except perhaps the mutilated edition of Verbiest's little handbook.

To describe one is to give a fair idea of all such native works for the diffusion of knowledge. We found in our little parcel a complete guide (save the mark!) to the *Fauna* and *Flora* of the Celestial Empire, besides a treatise headed "Philosophy for the Young," in which children are shown that to work for one's living is better than to be idle, and that the strength of three men is powerless against *Li*. Now as *Li* means "abstract right," and as it is an axiom of Chinese philosophy that "right in the abstract" does exist, we are gravely informed that neither the moral or physical violence of any three men acting in concert can hope to prevail against it. So much for the state of education in China at the present day, the remedy for which unwholesome condition will by no means readily be found. From time to time a few scientific treatises are translated by ambitious members of the missionary body, but such only tend to

swell the pastor's fame amongst his own immediate flock : they do not advance civilisation one single step. The very fact of their emanating from a missionary would of itself be enough to deter the better class of Chinese from purchasing, or even accepting them as a gift. *

* " The principal priest . . . declined the gift of some Christian books."—From *Glimpses of Travel in the Middle Kingdom,* published in the *Celestial Empire* of July 3d, 1875.

ROAMING in quest of novelty through that mine of marvels, a Chinese city, we were a witness the other day of a strange but not uncommon scene. We had halted in front of the stall of a street apothecary, surgeon, and general practitioner, and were turning over with our eyes his stock of simples, dragons' teeth, tigers'-claws, and like drugs used as ingredients in the native pharmacopeia, when along came a man, holding his hand up to his jaw, and apparently in great pain. He sat down by the doctor and explained to him that he was suffering with the toothache, to get rid of which he would like to have his tooth removed. The doctor opened his patient's mouth and inspected the aching tooth; then he took a small phial from his stock of medicines, and into the palm of his hand he shook a few scruples of a pink-coloured powder. He next licked his finger and dipped it into the powder, and inserting this into the man's mouth, rubbed it on the aching tooth and gum. He repeated this three or four times, and then concluded by turning the patient's head upside down; when, to the no small astonishment of many of the bystanders, among

whom was apparently the man himself, the tooth
dropped out and fell on the ground. The doctor then
asked him if he had felt any pain, to which he replied
that he had not, and the payment of a small fee
brought the *séance* to a close. At our application the
tooth was picked up and very civilly exhibited to us
by the owner himself: it was evidently fresh from a
human jaw, though there had not been the slightest
effusion of blood from the man's mouth. The thought
had naturally suggested itself to us that the whole
thing was a hoax, and that the patient was an accom-
plice; but if so, the doctor was no novice at sleight of
hand, and the expression of astonishment on the other
man's face when he found his tooth gone, was as per-
fect a specimen of histrionic emotion as it has ever
been our lot to behold.

That night we had visions of a large establishment
in Regent Street, with an enormous placard announc-
ing "Painless Dentistry" over the door, and crowds
of dukes and duchesses mounting and descending our
stairs to have their teeth extracted by some mysterious
process imported from China, and known to ourselves
alone. Next day we proceeded to rummage through
our Chinese medical library and see what we could
hunt up on the subject of dentistry. The result of
this search we generously offer to our readers, thus,
perhaps, sacrificing the chance of securing a colossal
fortune.

In the "New Collection of Tried Prescriptions," a
sort of domestic medicine published for the use of

families in cases of emergency when no physician is at hand, we find the following remarks :—

METHOD FOR EXTRACTING ACHING TEETH.

"A tooth ought not to be taken out, for by so doing the remaining teeth will be loosened. If the pain is very acute and interferes with eating or drinking, then the tooth may be extracted; otherwise it should be left. Take a bream about ten ounces in weight, rip it open and insert $\frac{1}{10}$ of an ounce of powdered arsenic. Then sew up the body and hang it up in the wind where it is not exposed to the sun or accessible to cats and rats. After being thus hung for seven days, a kind of hoar-frost will have formed upon the scales of the fish. Preserve this, using for each tooth about as much as covers one scale. When required, spread it on a piece of any kind of plaster, press it with the finger on to the aching place, and let it stick there. Then let the patient cough, and the tooth will fall out of itself. This prescription has been tested by Dr Wang."

ANOTHER METHOD.

"Take a head of garlic and pound it up to a pulp. Mix it up thoroughly with one or two candareens' weight of white dragon's bones, and apply it to the suffering part. In a little while the tooth will drop out."

It will be noticed that the above prescriptions are neither without one or other of two characteristics always to be found in the composition of Chinese remedies. In the first recipe, the ingredients are simple enough, and all that is required is time, seven days being necessary for its preparation. Now, as it is very unlikely that any one would collect the "hoar-frost" deposit from the scales of a bream stuffed with arsenic, in anticipation of a future toothache, and as he would probably have got well long before the expiration of the seven days if he set to work to make

c

his medicine only when the tooth began to ache, the genius of the physician and the efficacy of the recipe are alike secure from attack. In the second case, the very existence of one of the drugs mentioned is, to say the least, apocryphal; and although such can be purchased at the shops of native druggists, any complaint on the part of a duped patient would be met by the simple answer, that the white dragon's bones he bought could not possibly have been genuine !

A few days after the above incident, we returned to the dentist's stall, and asked him if he had any powder that would draw out a tooth by mere application to the gum or to the tooth itself? He replied that such a powder certainly existed, and was commonly manufactured in all parts of China, but that he himself was out of it at the moment. He added, that if we would call again on the 4th of the 4th moon, before 12 o'clock in the day, he should be in a position to satisfy our demands.

In conclusion, we append a quotation from the *China Review,* which appeared in print after our own sketch was written :—

" Despite the oft-repeated assertion as to painless, or at least easy, dentistry in China, very few people seem prepared to admit that teeth are constantly extracted in the way described by (I think) a former correspondent of the *Review.* He stated that a white powder was rubbed on the gums of the patient, after which the tooth was easily pulled from its socket; and this I can substantiate, noting, however, that the action of the powder (corrosive sublimate) is not quite so rapid as represented. A short time since I witnessed an operation of this kind. The

operator rubbed the powder on the gum as described, but then directed the patient to wait a little. After perhaps ten minutes' interval, he again rubbed the gum, and then introducing his thumb into the mouth, pressed heavily against the tooth (which was a large molar). The man winced for a second as I heard the 'click' of the separation, but almost before he could cry out, the dentist gripped the tooth with his forefinger and thumb, and with very little violence pulled it out. The gum bled considerably, and I examined the tooth so as to satisfy myself that there was no deception. It had an abscess at the root of the fang, and was undoubtedly what it professed to be. When the operation was over, the patient washed his mouth out with *cold* water, paid fifteen cash and departed."

IN spite of the glowing reports issued annually from various foreign hospitals for natives, and the undeniable good, though desultory and practically infinitesimal, that is being worked by those institutions, we cannot blind ourselves to the fact that western medical science is not making more rapid strides than many other innovations in the great struggle against Chinese prejudice and distrust. By far the majority of our servants and those natives who come most in contact with foreigners never dream of consulting a European doctor; or if they do, that is quite as much as can be said, for we may pronounce it a fact that they never take either his advice or his medicine. They still prefer to appear with large dabs of green plaster stuck on either temple, and to drink loathsome decoctions of marvellous drugs, compounded according to eternal principles laid down so many centuries ago. In serious cases, when they employ their own doctors, they are apt to mark, as Bacon said, the hits but not the misses; and failure of human skill is generally regarded as resulting from the interposition of divine will. Directly, however, a foreigner comes upon the scene they seem to forget at once that medicine is an

uncertain science, and expect not only a sure but an almost instantaneous recovery ; and, unfortunately, a single failure is quite enough to undo the good of many months of successful practice. One Chinaman bitterly complained to us of a foreign doctor, and sweepingly denounced the whole system of western treatment, because the practitioner alluded to had failed to cure his mother, aged eighty, of a very severe paralytic stroke. A certain percentage of natives are annually benefited by advice and medicine, both of which are provided gratis, and go home to tell the news and exhibit themselves as living proofs of the *foreign devils'* skill ; but in many instances their friends either believe that magical arts have been brought to bear, or that after all a Chinese doctor would have treated the case with equal success, and accordingly the number of patients increases in a ratio very disproportionate to the amount of good really effected. Besides, if faith in European doctors was truly spreading to any great extent, we should hear of wealthy Chinamen regularly calling them in and contributing towards the income of those now in full practice at the Treaty ports. It is absurd to point to isolated cases in a nation of several hundred millions, and argue that progress is being made because General This or Prefect That consented to have an abscess lanced by a foreign surgeon, and sent him a flowery letter of thanks with a couple of Chinese hams the day after the operation. The Chinese as a people laugh at our medical science, and, we are bound to

say, with some show of justice on their side. They have a medical literature of considerable extent, and though we may condemn it wholesale as a farrago of utter nonsense, it is not so to the Chinese, who fondly regard their knowledge in this branch of science as one among many precious heirlooms which has come down to them from times of the remotest antiquity.

We alluded in the last Sketch to a work in eight small volumes called " New Collection of Tried Prescriptions," a book which answers to our "Domestic Medicine," and professes to supply well-authenticated remedies for some of the most common ills that flesh is heir to. This book gives a fair idea of the principles and practice of medical science in China. It is divided into sections and subdivided into chapters under such headings as the *eye*, the *teeth*, the *hand*, the *leg*, &c. &c. We gave a specimen of the prescriptions herein brought together in our late remarks upon the methods of extracting teeth, but it would be doing an injustice to the learning of its author if we omitted to point out that in this book remedies are provided, not only for such simple complaints as chilblains or the stomach-ache, but for all kinds of serious complications arising from the evil influence of demons or devils. One whole chapter is devoted to "Extraordinary Diseases," and teaches anxious relatives to give instant relief in cases of " the face swelling as big as a peck measure, and little men three feet long appearing in the eyes." "Seeing one thing as if it were two" would hardly

be classed by London doctors as an extraordinary disease, and is not altogether unknown even amongst foreigners in China. "Seeing things upside down after drinking wine," belongs to the same category, and may be cited in proof of a position taken up by most observers, namely, that the Chinese are a sober people. "Seeing kaleidoscopic views which turn to beautiful women," "the flesh becoming hard as a stone and sounding like a bell when tapped," "objecting to eat in company," and such diseases have each a special prescription offered by the learned Dr Wang with the utmost gravity, and accepted in good faith by many a confiding patient.

Chinamen look with suspicion on the sober treatment of the West, where no joss-stick is burnt, and no paper money is offered on the altar of some favourite P'u-sa; though, if they knew the whole truth, they would discover that intercessory prayers for the recovery of sick persons are considered by many of us to be of equal importance with the administration of pills and draughts. Further, like our own agricultural classes, they have no faith in medicine of any kind which does not make its presence felt not only quickly but powerfully. This last desire was amply fulfilled in the case of one poor coolie who applied to an acquaintance of ours for some foreign medicine to cure a sick headache and bilious attack from which he was suffering. Our friend immediately bethought himself of a Seidlitz powder; but when all was ready, the acid in one wine-glass of water and

the salt in another, the devil entered into him, and he gave them to his victim to drink one after the other. The result was indescribable, for the mixture *fizzed inside,* and the unfortunate coolie passed such a *mauvais quart d'heure* as effectually to cure his experimenting master from any further indulgence in practical jokes of so extremely dangerous a nature.

LUXURIATING in the " mental oasis" of Chinese litera-
ture in general, and the " New Collection of Tried
Prescriptions" in particular, we have been tempted
to carry our researches still further in that last-men-
tioned valuable work. It would have been sufficient
to establish the reputation of any European treatise
on medical science had it contained one such simple
and efficacious method for extracting teeth as we gave
in our chapter on Dentistry ; but Chinese readers are
not so easily satisfied, and it takes something more
than mere remedies for coughs, colds, lumbago, or the
gout, to ensure a man a foremost place among the
Galens of China. Even a chapter on " Extraordinary
Diseases," marvellous indeed in the eyes of the scep-
tical barbarian, is not enough for the hungry native
mind ; and nothing less than a whole section of the
most miraculous remedies and antidotes, for and
against all kinds of unheard-of diseases and poisons,
would suffice to stamp the author as a man of genius,
and his work as the offspring of successful toil in the
fields of therapeutic science. Thus it comes about
that the author of the " New Collection of Tried Pre-
scriptions" gathers together at the close of his last

volume such items of experience in his professional career as he has not been able to introduce into the body of his book, and from this chapter we purpose to glean a few of the most striking passages.

To begin with : Mr Darwin will be delighted to hear, if this should ever meet his eye, that the growth of tails among mankind in China is not limited to the appendage of hair which reposes gracefully on the back, and saturates with grease the outer garment of every high or low born Celestial. Elongation of the spine is, at any rate, common enough for Dr Wang to treat it as a disease and specify the remedy, which consists in tying a piece of medicated thread tightly round it, and tightening the thread from time to time until the tail drops off. In order, however, to guard against its growing again, a course of medicine has to be taken, whereby any little irregularities of the *yin* or female principle* may be corrected, and the unpleasant tendency at once and for ever checked.

We then come to elaborate directions for the extirpation of all kinds of parasites, white ants, mosquitoes, &c. ; but judging from the plentiful supply of such pests in every part of China, we can only conclude that the natives are apathetic as regards these trifles, and do not suffer the same inconvenience therefrom as the more delicately-nurtured barbarian. The next

* The symbol of the *yin* and the *yang*, or male and female principles, has been used in the beading of the cover to this volume. The dark half is the *yin*, the other the *yang*.

heading would somewhat astonish us, accustomed as we are to the vagaries of Chinese book-makers, were it not that the section upon which we are engaged is supposed to contain "miscellaneous" prescriptions, which may include anything, though it is a somewhat abrupt transition for a grave medical work to pass from the destruction of insects to a remedy against *fires!*

" Take three fowl's-eggs, and write at the big end of each the word *warm*, at the small end the word *beautiful*. Then throw them singly to the spot where the fire is burning brightest, uttering all the time ' fooshefahrun, fooshefahrun.' The fire will then go out." There are several other methods, but perhaps this one will be found to answer the purpose.

Further on we find a most practicable way for pedestrians of discovering the right direction to pursue at a cross road. " Carry with you a live tortoise, and when you come to a cross road and do not know which one to choose, put down the tortoise and follow it. Thus you will not go wrong." For people who are afraid of seeing bogies at night, the following is recommended :—" With the middle finger of the right hand trace on the palm of the left hand the words *I am a devil*, and close your hand up tight. You will then be able to travel without fear." Sea-sickness may be prevented by drinking the drippings from a bamboo punt-hole mixed with boiling water, or by inserting a lump of burnt mortar from a stove into the hair, without letting anybody know it is there ;

also by writing the character *earth* on the palm of the hand previous to going on board ship. Ivory may be cleaned to look like new by using the whey of bean-curd, and rice may be protected from weevils and maggots by inserting the shell of a crab in the place where it is kept. The presence of bad air in wells may be detected by letting a fowl's feather drop down: if it falls straight, the air is pure; if it circles round and round, poisonous. Danger may be averted by throwing in a quantity of hot vinegar before descending. A fire may be kept alight from three to five days without additional fuel by merely putting a walnut among the live ashes; and a method is also given to make a candle burn many hours with hardly any perceptible decrease in size.

We close Dr Wang's "New Collection of Tried Prescriptions" with mingled feelings of admiration and regret: admiration, not indeed for the genius of its author, or any new light which may have been let in upon us during our study of this section of the "mental oasis" of Chinese literature, but for the indomitable energy and skill of those who have helped to emancipate us from similar trammels of ignorance and folly; regret, that a nation which carries within its core the germs of a transcendent greatness should still remain sunk in the lowest depths of superstitious gloom.

In a country where money is only obtainable at such an exorbitant rate of interest as in China, it is but natural that some attempt should be made to obviate the necessity of appealing to a professional money-lender. Three per cent. per month is the maximum rate permitted by Chinese law, which cannot be regarded as excessive if the full risk of the lender is taken into consideration. He has the security of one or more "middlemen," generally shopkeepers whose solvency is unimpeachable; but these gentlemen may, and often do, repudiate their liability without deigning to explain either why or wherefore. His course is then not quite so plain as it ought to be under a system of government which has had some two thousand years to mature. Creditors as well as debtors shun the painted portals of the magistrate's yamen* as they would the gates of hell. Above them is traced the same desperate legend that frightened the soul of DANTE when he stood before the entrance to the infernal regions. Truly there is no hope for those who enter there. Both sides are *squeezed* by the gate-keeper—a very lucrative post in all yamens

* Official and private residence, all in one.

—before they are allowed to present their petitions. It then becomes necessary for plaintiff and defendant alike to go through the process of (in Peking slang) " making a slit," *i.e.*, making a present of money to the magistrate and his subordinates proportionate to the interests involved. In many yamens there is a regular scale of charges, answering to our Table of Fees, but this is almost always exceeded in practice. The case is then heard : occasionally, on its merits. We say occasionally, because nine times out of ten one of the parties bids privately for the benefit of his honour's good opinions. Sometimes both suitors do this, and then judgment is knocked down to the highest bidder. The loser departs incontinently cursing the law and its myrmidons to the very top of his bent, and perhaps meditating an appeal to a higher court, from which he is only deterred by prospects of further expense and repeated failure. As to the successful litigant, he would go on his way rejoicing, but that he has a duty to perform before which he is not a free man. The " slit " he made on entering the yamen needs to be re-paired, and on him devolves the necessity of " sewing it up." The case is then at an end, and the prophecy fulfilled, which says :—

> " The yamen doors are open wide
> To those with *money* on their side."

Wiser and more determined creditors take the law into their own hands. With a tea-pot, a pipe, and a mattress, they proceed to the shop of the recalcitrant debtor or security as circumstances may dictate, and

there take up their abode until the amount is paid.
If inability to meet the debt has been pleaded, then
this self-made bailiff will insist on taking so much per
cent. out of the daily receipts ; if it is a mere case of
obstinacy, a desire to shirk a just responsibility, the
place is made so hot for its owner that he is glad to
get rid of his visitor at any price whatever. Were
manual violence resorted to, the interference of the
local officials would be absolutely necessary ; and in
all cases where personal injuries are an element, their
action is not characterised by the same tyranny and
corruption as where only property is at stake. The
chances are that the aggressor would come off worst.

To protect themselves, however, from such a prohi-
bitive rate of usury as that mentioned above, Chinese
merchants are in the habit of combining together and
forming what are called Loan Societies for the mutual
benefit of all concerned. Such a society may be
started in the first instance by a deposit of so much
per member, which sum, in the absence of a volunteer,
is handed over to a manager, elected by a throw of
dice, whose business it is to lay out the money during
the ensuing month to the best possible advantage.
Frequently one of the members, being himself in want
of funds, will undertake the job ; and he, in common
with all managers, is held responsible for the safety of
the loan. At the end of the month there is a meeting ·
at which the past manager is bound to produce the
entire sum entrusted to his charge, together with any
profits that may have accrued meanwhile. Another

member volunteers, or is elected manager, and so the thing goes on, a running fund from which any member may borrow, paying interest at a very low rate indeed. Dividends are never declared, and consequently some of these clubs are enormously rich ; but any member is at liberty to withdraw whenever he likes, and he takes with him his share of all moneys in the hands of the Society at the moment of his retirement. To outsiders, the market rate of interest is charged, or perhaps a trifle less, but loans are only made upon the very best securities.

In every large Chinese city are to be found several spacious buildings which are generally reckoned among the sights of the place, and are known by foreigners under the name of guilds. Globe-trotters visit them, and admire the maximum of gold-leaf crowded into the minimum of space, their huge idols, and curious carving ; of course passing over those relics which the natives themselves prize most highly, namely, sketches and scrolls painted or written by the hand of some departed celebrity. Foreign merchants regard them with a certain amount of awe, for they are often made to feel keenly enough the influence which these institutions exert over every branch of trade. They come into being in the following manner. If traders from any given province muster in sufficient numbers at any of the great centres of commerce, they club together and form a guild. A general subscription is first levied, land is bought, and the necessary building is erected. Regulations are then drawn up, and the tariff on goods is fixed, from which the institution is to derive its future revenue. For all the staples of trade there are usually separate guilds, mixed establishments being comparatively rare. It is the business

D

of the members as a body to see that each individual
contributes according to the amount of merchandise
which passes through his hands, and the books of sus-
pected defaulters are often examined at a moment's
notice and without previous warning. The guild
protects its constituents from commercial frauds by
threatening the accused with legal proceedings which
an individual plaintiff would never have dared to
suggest; and the threat is no vain one when a man-
darin, however tyrannical and rapacious, finds himself
opposed by a body of united and resolute men. On
the other hand, these guilds deal fairly enough with
their own members, and not only refuse to support a
bad case, but insist on just and equitable dealings with
the outside world. To them are frequently referred
questions involving nice points of law or custom, and
one of the chief functions of a guild is that of a court
of arbitration. In addition to this they fix the market
rates of all kinds of produce, and woe be to any
one who dares to undersell or otherwise disobey the
injunctions of the guild. If recalcitrant, he is expelled
at once from the fraternity, and should his hour of
need arrive he will find no helping hand stretched
out to save him from the clutches of the law. But if
he acknowledges, as he almost always does, his breach
of faith, he is punished according to the printed rules
of the corporation. On a large strip of red paper his
name and address are written, the offence of which he
has been convicted, and the fine which the guild has
determined to impose. This latter generally takes the

form of a dinner to all the members, to be held on some appointed day and accompanied by a theatrical entertainment, after which the erring brother is admitted as before to the enjoyment of those rights and privileges he would otherwise infallibly have lost.

On certain occasions, such as the birthday of a patron saint, the guild spends large sums from the public purse in providing a banquet for its members and hiring a theatrical troupe, with their everlasting tom-toms, to perform on the permanent stage to be found in every one of these establishments. The Anhui men celebrate the birthday of CHU HSI, the great commentator, whose scholarship has won eternal honours for his native province ; Swatow men hold high festival in memory of HAN WEN-KUNG, whose name is among the brightest on the page of Chinese history. All day long the fun goes on, and as soon as it begins to grow dusk innumerable paper lanterns are hung in festoons over the whole building. The crowd increases, farce succeeds farce without a moment's interval, and many a kettle of steaming wine warms up the spectators to the proper pitch of enthusiasm and delight. Before midnight the last song has been sung, a considerable number of people have quietly dispersed without accident of any kind, and the courtyard of the guild is once more deserted and still.

It is open to any trader to join the particular institution which represents his own province or trade without being either proposed, seconded, or balloted

for. He is expected to make some present to the
resources of the guild, in the shape of a new set of
glass lanterns, a pair of valuable scrolls, some new
tables, chairs, or in fact anything that may be needed
for either use or ornament. Should he be in want of
money, a loan will generally be issued to him even on
doubtful security. Should he die in an impoverished
condition, a coffin is always provided, the expenses of
burial undertaken, and his wife and children sent to
their distant home, with money voted for that purpose
at a general meeting of the members. Were it not
for the action of these guilds in regard to fire, life and
property in Chinese cities would be more in danger
than is now the case. Each one has its own fire-
engine, which is brought out at the first alarm, no
matter where or whose the building attacked. If be-
longing to one of themselves, men are posted round
the scene of the conflagration to prevent looting on
the part of the crowd, and the efforts of the brigade
are stimulated by the reflection that their position and
that of the present sufferers may at any moment be
reversed. Picked men are appointed to perform the
most important task of all, that of rescuing from the
flames relics more precious to a respectable Chinaman
than all the jade that K'un-kang has produced. For
it often happens that an obstructive geomancer will
reject site after site for the interment of some deceased
relative, or perhaps that the day fixed upon as a lucky
one for the ceremony of burial may be several months
after death. Meanwhile a fire breaks out in the

house where the body lies in its massive, air-tight coffin, and all is confusion and uproar. The first thought is for the corpse; but who is to lift such a heavy weight and carry it to a place of safety without the dreaded jolting, almost as painful to the survivors as would be cremation itself? Such harrowing thoughts are usually cut short by the entrance of six or eight sturdy men from the nearest guild, who, armed with the necessary ropes and poles, bear away the coffin through flame and smoke with the utmost gentleness and care.

FEW probably among our readers have had much experience on the subject of the present sketch—a Chinese pawnshop. Indeed, for others than students of the manners and customs of China, there is not much that is attractive in these haunts of poverty and vice. The same mighty misery, which is to be seen in England passing in and out of mysterious-looking doors distinguished by a swinging sign of three golden balls, is not wanting to the pawnshop in China, though the act of pledging personal property in order to raise money is regarded more in the light of a business transaction than it is with us, and less as one which it is necessary to conceal from the eyes of the world at large. Nothing is more common than for the owner of a large wardrobe of furs to pawn them one and all at the beginning of summer and to leave them there until the beginning of the next winter. The pawnbrokers in their own interest take the greatest care of all pledges, which, if not redeemed, will become their own property, though they repudiate all claims for damage done while in their possession ; and the owner of the goods by payment of the interest charged is released from all trouble and annoyance.

Pawnshops in China are divided into three classes, one of which has since the days of the T'ai-p'ings totally disappeared from all parts over which the tide of rebellion passed. This is the *tien tang*, where property could be left for three years without forfeit, and to establish which it was necessary to obtain special authority from the Board of Revenue in Peking. At present there are the *chih tang* and the *ssŭ ya*, both common to all parts of China, and to these we shall confine our remarks. The former, which may be considered as the pawnshop proper, is a private institution as far as its business is concerned, but licensed on payment of a small fee by the local officials, and regulated in its workings by certain laws which emanate from the Emperor himself. A limit of sixteen months is assigned, within which pledges must be redeemed or they become the property of the pawnbroker; and the interest charged, formerly four per cent., is now fixed at three per cent. *per month.* Before the license above-mentioned can be obtained, security must be provided for the existence of sufficient capital to guard against a sudden or a fraudulent collapse. For any article not forthcoming when the owner desires to redeem it, double the amount of the original loan is recoverable from the pawnbroker. Should any owner of a pledge chance to lose his ticket by theft or otherwise, he may proceed to the pawnshop with two substantial securities, and if he can recollect the number, date, and amount of the transaction, another ticket is issued to him with which he may recover his property

at once, or at any time within the original sixteen
months. Pawn-tickets are not unseldom offered as
pledges, and are readily received, as the loan is never
more than half the value of the deposit ; and tickets
thus obtained are often sold either to a third person
or perhaps to the pawnbroker who issued them in the
first instance. Formerly, when the interest payable
was four per cent. per month, it was a standing rule
that during the last three months in every year, *i.e.*,
the winter season, pledges might be redeemed at a
diminished rate, so that poor people should have a
better chance of getting back their wadded clothes to
protect them from the inclemency of frost and cold.
But since the rate of interest has been reduced to three
per cent. this custom has almost passed away ; its
observance is, however, sometimes called for by a
special proclamation of the local magistrate when the
necessaries of life are unusually dear, and the times
generally are bad. The following is a translation of
a ticket issued by one of these shops, which may often
be recognised in a Chinese city by the character for
pawn painted on an enormous scale in some conspicu-
ous position :—" In accordance with instructions from
the authorities, interest will be charged at the rate of
three per cent. [per month] for a period of sixteen
months, at the expiration of which the pledge, if not
redeemed, will be comethe property of the pawnbroker,
to be disposed of as he shall think fit. All damages
to the deposit arising from war, the operations of
nature, insects, rats, mildew, &c,, to be accepted by

both sides as the will of Heaven. Deposits will be returned on presentation of the proper ticket without reference to the possession of it by the applicant." Besides this, the name and address of the pawnshop, a number, description of the article pledged, amount lent, and finally the date, are entered in their proper places upon the ticket, which is stamped as a precaution against forgery with the private stamp of the pawnshop. Jewels are not received as pledges, and gold and silver only under certain restrictions.

The other class is not recognised by the authorities, and its very existence is illegal, though of course winked at by a venial executive. Shops of this kind, which may be known by the character for *keep*, are very much frequented by the poor. A more liberal loan is obtainable than at the licensed pawnbroker's, but on the other hand the rate of interest charged is very much more severe. Pledges are only received for three months, and on the ticket issued there is no stipulation about damage to the deposit. No satisfaction is to be got in case of fraud or injustice to either side : a magistrate would refuse to hear a case either for or against one of these unlicensed shops. They carry on their trade in daily fear of the rowdies who infest every Chinese town, granting loans to these ruffians on valueless articles, which in many cases are returned without payment either of interest or principal, thereby securing themselves from the disturbances which "bare poles" who have nothing to lose are ever ready to create at a moment's notice, and

which would infallibly hand them over to the clutches
of hungry and rapacious officials. The counters over
which all business is transacted are from six to eight
feet high, strongly made, and of such a nature that to
scale them would be a very difficult matter, and to
grab anything with the view of making a bolt for the
street utterly and entirely impossible. In a Chinese
city, where there is no police force to look after the
safety of life and property, and where everybody pre-
fers to let a thief pass rather than risk being called as
a witness before the magistrate, it becomes necessary
to guard against such contingencies as these. As
things are now, pawnshops may be considered the
most flourishing institutions in the country; and in
these establishments many even of the highest officials
invest savings squeezed from the districts entrusted
to their paternal care.

MANY residents in China are profoundly ignorant of the existence of a native postal service; and even the few who have heard of such an institution, are not aware of the comparative safety and speed with which even a valuable letter may be forwarded from one end of the Empire to the other. Government despatches are conveyed to their destinations by a staff of men specially employed for the purpose, and under the control of the Board of War in Peking. They ride from station to station at a fair pace, considering the sorry, ill-fed nags upon which they are mounted; important documents being often carried to great distances, at a rate of two hundred miles a-day. The people, however, are not allowed to avail themselves of this means of communication, but the necessities of trade have driven them to organise a system of their own.

In any Chinese town of any pretensions whatever, there are sure to be several "letter offices," each monopolising one or more provinces, to and from which they make it their special business to convey letters and small parcels. The safety of whatever is entrusted to their care is guaranteed, and its value made good if lost; at the same time, the contents of

all packets must be declared at the office where posted,
so that a corresponding premium may be charged for
their transmission. The letter-carriers travel chiefly
on foot, sometimes on donkeys, to be found on all the
great highways of China, and which run with unerring
accuracy from one station to another, unaccompanied
by any one except the hirer. There is little danger
of the donkeys being stolen, unless carried off bodily,
for heaven and earth could no more move them from
their beaten track than the traveller who, desirous of
making two stages without halting, could induce them
to pass the door of the station they have just arrived
at. Carrying about eighty or ninety pounds weight
of mail matter, these men trudge along some five miles
an hour till they reach the extent of their tether;
there they hand over the bag to a fresh man, who
starts off, no matter at what hour of the day or night,
and regardless of good or bad weather alike, till he
too has quitted himself of his responsibility by pass-
ing on the bag to a third man. They make a point
of never eating a full meal; they eat themselves, as
the Chinese say, six or seven tenths full, taking food
as often as they feel at all hungry, and thus preserve
themselves from getting broken-winded early in life.
Recruited from the strongest and healthiest of the
working-classes, it is above all indispensable that the
Chinese letter-carrier should not be afraid of any
ghostly enemy, such as bogies or devils. In this re-
spect they must be tried men before they are entrusted
with a mail; for an ordinary Chinaman is so instinc-

tively afraid of night and darkness, that the slightest
rustle by the wayside would be enough to make him
fling down the bag and take to his heels as if all the
spirits of darkness had been loosed upon him at one
and the same moment.

The scale of charges is very low. The cost of send-
ing a letter from Peking to Hankow—650 miles, as
the crow flies—being no more than eight cents, or
fourpence. About thirty per cent. of the postage is
always paid by the sender, to secure the office against
imposition and loss; the balance is recoverable from
the person to whom the letter is addressed. These
offices are largely used by merchants in the course of
trade, and bills of exchange are constantly being thus
sent, while the banks forward the foil or other half to
the house on which it is drawn, receipt of which is
necessary before the draft can be cashed. Such docu-
ments, together with small packets of sycee, make up a
tolerably valuable bag, and would often fall a prey to
the highwaymen which infest many of the provinces,
but that most offices anticipate these casualties by
compounding for a certain annual sum which is paid
regularly to the leader of the gang. For this black-
mail the robbers of the district not only agree to
abstain from pilfering themselves, but also to keep all
others from doing so too. The arrangement suits the
local officials admirably, as they escape those pains and
penalties which would be exacted if it came to be
known that their rule was too weak, and their example
powerless to keep the district free from the outrages

of thieves and highwaymen. Large firms, which
supply carts to travellers between given points, are
also often in the habit of contracting with the brigands
of the neighbourhood for the safe passage of their
customers. In some parts soldiers are told off by the
resident military officials to escort travellers who leave
the inns before daybreak, until there is enough light
to secure them against the dangers of a sudden attack.
In others, there are bands of trained men who hire
themselves out in companies of three or five to convey a
string of carts with their dozen passengers across some
dangerous part of the country, where it is known that
foot-pads are on the look-out for unwary travellers.
The escort consists of this small number only, for the
reason that each man composing it is supposed to be
equal to five or six robbers, not in mere strength, but
in agility and knowledge of sword-exercise. To
accustom themselves to the attacks of numbers, and
to acquire the requisite skill in fighting more than one
adversary at a time, these men practise in the follow-
ing remarkable manner. In a lofty barn heavy bags
of sand are hung in a circle by long ropes to the roof,
and in the middle of these the student takes up his
position. He then strikes one of the bags a good
blow with his fist, sending it flying to a distance from
him, another in the same way, then another, and so
on until he has them all swinging about in every
possible direction. By the time he has hit two or
three it is time to look out for the return of the first,
and sometimes two will come down on him at once

from opposite quarters; his part is to be ready for all emergencies, and keep the whole lot swinging without ever letting one touch him. If he fails in this, he must not aspire to escort a traveller over a lonesome plain; and, besides, the ruthless sand-bag will knock him head over heels into the bargain.

ALTHOUGH native scholars in China have not deemed it worth while to compile such a work as the "Slang Dictionary," it is no less a fact that slang occupies quite as important a position in Chinese as in any language of the West. Thieves have their *argot*, as with us, intelligible only to each other ; and phrases constantly occur, even in refined conversation, the origin of which can be traced infallibly to the kennel. *Why so much paint?* is the equivalent of *What a swell you are!* and is specially expressive in China, where beneath a flowered blue silk robe there often peeps out a pair of salmon-coloured inexpressibles of the same costly material. *They have put down their barrows,* means that certain men have struck work, and is peculiarly comprehensible in a country where so much transport is effected in this laborious way. Barrows are common all over the Empire, both for the conveyance of goods and passengers ; and where long distances have to be traversed, donkeys are frequently harnessed in front. The traditional sail is also occasionally used : we ourselves have seen barrows running before the wind between Tientsin and Taku, of course with a man pushing behind. *The children*

have official business, is understood to mean they are laid up with the small-pox; the metaphor implying that their *turn* has come, just as a turn of official duty comes round to every Manchu in Peking, and in the same inevitable way. Vaccination is now gradually dispelling this erroneous notion, but the phrase we have given is not likely to disappear.

A magistrate who has *skinned the place clean,* has extorted every possible· cash from the district committed to his charge—a "father and mother" of the people, as his grasping honour is called. *That horse has a mane,* says the Chinese housebreaker, speaking of a wall well studded at the top with pieces of broken glass or sharp iron spikes. *You'll have to sprinkle so much water,* urges the friend who advises you to keep clear of law, likening official greed to dust, which requires a liberal outlay of water in the shape of banknotes to make it lie. A *flowery bill* is understood from one end of China to the other as that particular kind in which our native servants delight to indulge, namely, an account charging twice as much for everything as was really paid, and containing twice as much in quantity as was actually supplied. A *flowery suit* is a case in which women play a prominent part. *You scorched me yesterday* is a quiet way of remarking that an appointment was broken, and implying that the rays of the sun were unpleasantly hot. *Don't pick out the sugar* is a very necessary injunction to a servant sent to market to buy food, &c., the metaphor being taken from a kind of sweet dumpling consumed

E

in great quantities by rich and poor alike. Another phrase is, *Don't ride the donkey*, which may be explained by the proverbial dislike of Chinamen for walking exercise, and the temptation to hire a donkey, and squeeze the fare out of the money given them for other purposes. *That house is not clean inside*, signifies that devils and bogies, so dreaded by the Chinese, have taken up their residence therein; in fact, that the house is haunted. *He's all rice-water, i.e.*, gives one plenty of the water in which rice has been boiled, but none of the rice itself, is said of a man who promises much and does nothing. *One load between the two*, is very commonly said of two men who have married two sisters. In China, a coolie's "load" consists of two baskets or bundles slung with ropes to the end of a flat bamboo pole about five feet in length, and thus carried across the shoulder. Hence the expression. Apropos of marriage, *the guitar string is broken*, is an elegant periphrasis by which it is understood that a man's wife is dead, the verb "to die" being rarely used in conversation, and never of a relative or friend. He will not *put a new string to his guitar* is, of course, a continuation of the same idea, more coarsely expressed as *putting on a new coat*. His father has been *gathered to the west*—a phrase evidently of Buddhistic import—*is no more, has gone for a stroll, has bid adieu to the world*, may all be employed to supply the place of the tabooed verb, which is chiefly used of animals and plants. After a few days' illness *he kicked*, is a vulgar way of putting

it, and analogous to the English slang idiom. The Emperor *becomes a guest on high,* riding up to heaven on the dragon's back, with flowers of rhetoric ad nauseam; Buddhist priests *revolve into emptiness,* *i.e.,* are annihilated; the soul of the Taoist priest *wings its flight away.*

Only a candle-end left is said of an affair which nears completion; *red* and *white matters* are marriages and deaths, so called from the colour of the clothes worn on these important occasions. A blushing person *fires up,* or literally, *ups fire,* according to the Chinese idiom. To be fond of *blowing* resembles our modern term *gassing.* A *lose-money-goods* is a daughter as compared with a son who can go out in the world and earn money, whereas a daughter must be provided with a dowry before any one will marry her. A more genuine metaphor is a *thousand ounces of silver;* it expresses the real affection Chinese parents have for their daughters as well as their sons. To *let the dog out* is the same as our letting the cat out; to *run against a nail* is allied to kicking against the pricks. A man of superficial knowledge is called *half a bottle of vinegar,* though why vinegar, in preference to anything else, we have not been able to discover. He has always *got his gun in his hand* is a reproach launched at the head of some confirmed opium debauchee, one of those few reckless smokers to whom opium is indeed a curse. They have *burnt paper together,* makes it clear to a Chinese mind that the persons spoken of have gone through the marriage

service, part of which ceremony consists in burning
silver paper, made up to resemble lumps of the pure
metal. *We have split* is one of those happy idioms
which lose nothing in translation, being word for word
the same in both languages, and with exactly the same
meaning. *A crooked stick* is a man whose eccentricities
keep people from associating freely with him ; he won't
lie conveniently in a bundle with the other sticks.

We will bring this short sketch to a close with one
more example, valuable because it is old, because the
date at which it came into existence can be fixed with
unerring certainty, and because it is commonly used
in all parts of China, though hardly one educated man
in ten would be able to tell the reason why. A jealous
woman is said *to drink vinegar*, and the origin of the
term is as follows :—Fang Hsüan-ling was the favourite
Minister of the Emperor T'ai Tsung, of the T'ang
dynasty. He lived A.D. 578–648. One day his
master gave him a maid of honour from the palace as
second wife, but the first or real wife made the place
too hot for the poor girl to live in. Fang complained
to the Emperor, who gave him a bowl of poison, tell-
ing him to offer his troublesome wife the choice be-
tween death and peaceable behaviour for the future.
The lady instantly chose the former, and drank up the
bowl of *vinegar*, which the Emperor had substituted
to try her constancy. Subsequently, on his Majesty's
recommendation, Fang sent the young lady back to
resume her duties as tire-woman to the Empress. But
the phrase lived, and has survived to this day.

EVERYBODY who has frequented the narrow, dirty streets of a Chinese town must be familiar with one figure, unusually striking where all is novel and much is grotesque. It is that of an old man, occasionally white-bearded, wearing a pair of enormous spectacles set in clumsy rims of tortoiseshell or silver, and sitting before a small table on which are displayed a few mysterious-looking tablets inscribed with characters, paper, pencils, and ink. We are in the presence of a fortune-teller, a seer, a soothsayer, a vates ; or better, a quack who trusts for his living partly to his own wits, and partly to the want of them in the credulous numskulls who surround him. These men are generally old, and sometimes blind. Youth stands but a poor chance among a people who regard age and wisdom as synonymous terms; and it seems to be a prevalent belief in China that those to whom everything in the present is a sealed book, can for this very reason see deeper and more clearly into the destinies of their fellows. It is not until age has picked out the straggling beard with silver that the vaticinations of the seer are likely to spread his reputation far beyond the limits of the street in which he practises.

Younger competitors must be content to scrape together a precarious existence by preying on the small fry which pass unheeded through the meshes of the old man's net. Just as there is no medical diploma necessary for a doctor in China, so any man may be a fortune-teller who likes to start business in that particular line. The ranks are recruited generally from unsuccessful candidates at the public examinations ; but all that is really necessary is the minimum of education, some months' study of the art, and a good memory. For there really are certain principles which guide every member of the fraternity. These are derived from books written on the subject, and are absolutely essential to success, or nativities cast in two different streets would be so unlike as to expose the whole system at once. The method is this. A customer takes his seat in front of the table and consults the wooden tablet on which is engraved a scale of charges as follows :—

Foretelling any single event,	. . .	8	cash.
Do. do. with joss-stick,		16	do.
Telling a fortune,	28	do.
Do. in detail,	. . .	50	do.
Do. by reading the stars,	.	50	do.
Fixing the marriage-day,	. . According to agreement.		

In case he merely wants an answer on a given subject, he puts his question and receives the reply at once on a slip of paper. But if he desires to have his fortune told, he dictates the year, month, day, and hour of his birth, which are written down by the sage

in the particular characters used by the Chinese to express times and seasons. From the combinations of these and a careful estimate of the proportions in which the five elements—gold, wood, water, fire, and earth—make their appearance, certain results are deduced upon which details may be grafted according to the fancy of the fortune-teller. The same combinations of figures, *i.e.*, characters, will always give the same resultant in .the hands of any one who has learned the first principles of his art; it is only in the reading, the explanation thereof, that any material difference can be detected between the reckonings of any two of these philosophers, which amounts to saying that whoever makes the greatest number of happy hits beyond the mere technicalities common to all, is esteemed the wisest prophet and will drive the most flourishing trade.

Fully believing in the Chinese household word which says "Ignorance of any one thing is always one point to the bad," we have several times read our destiny through the medium of some dirty old Chinaman. On the last occasion we received the following advice in return for our 50 cash, paid as per tablet for a destiny in detail :—"Beware the odd months of this year : you will meet with some dangers and slight losses. Three male phœnixes (sons) will be accorded to you. Your present lustrum is not a fortunate one; but it has nearly expired, and better days are at hand. Fruit cannot thrive in the winter. (We had placed our birthday in the 12th moon.)

Conflicting elements oppose : towards life's close pre-
pare for trials. Wealth is beyond your grasp ; but
nature has marked you out to fill a lofty place." How
the above was extracted from the eight characters
which represented the year, month, day, and hour of
our birth, is made perfectly clear by a sum showing
every step in the working of the problem, though we
must confess it appeared to us a humbugging jumble,
the most prominent part of which was the answer.
We found among other things that *earth* predominated
in the combination : hence our inability to grasp wealth.
Water was happily deficient, and on this datum we
were blessed in anticipation with three sons, to say
nothing of daughters.

And this is the sort of trash that is crammed down
the throats of China's too credulous children—the
" babies," as the Mandarins are so justly fond of call-
ing them. For this rubbish they freely spend their
hard-earned wages, consulting some favourite prophet
on most of their domestic and other affairs with the
utmost gravity and confidence. Few Chinamen make
a money venture without first applying to the oracle,
and certainly never marry without arranging a lucky
day for the event. Ignorance and credulity combine
to support a numerous class of the most consummate
adepts in the art of swindling ; the supply, however,
is not more than adequate to the demand, albeit
they swarm in every street and thoroughfare of a
Chinese city.

CHINAMEN suffer horribly from *ennui*—especially the first of the four classes into which the non-official world has been subdivided.* They have no rational amusements wherewith to fill up the intervals of work. They hate physical exercise ; more than that, they despise it as fit only for the ignorant and low. Yet they have not supplied its place with anything intellectual, and the most casual observer cannot fail to notice that China has no national game. Fencing, rowing, and cricket, are alike unknown ; and archery, such as it is, claims the attention chiefly of candidates for official honours. Within doors they have chess, but it is not the game Europeans recognise by that name, nor is it even worthy of being mentioned in the same breath. There is also another game played with three hundred and sixty black and white pips on a board containing three hundred and sixty-one squares, but this is very difficult and known only to the few. It is said to have been invented by His Majesty the Emperor Yao who lived about two thousand three hundred and fifty years before Christ, so that granting an error of a couple of

* Namely, (1) the literati, (2) agriculturalists, (3) artisans, and (4) merchants or tradesmen.

thousand years or so, it is still a very ancient pastime. Dominoes are known, but not much patronised; cards, on the other hand, are very common, the favourite games being those in which almost everything is left to chance. As to open-air amusements, youths of the baser sort indulge in battledore and shuttlecock without the battledore, and every resident in China must have admired the skill with which the foot is used instead, at this foot-shuttlecock game. Twirling heavy bars round the body, and gymnastics generally, are practised by the coolie and horse-boy classes; but the disciple of Confucius, who has already discovered how "pleasant it is to learn with a constant perseverance and application," * would stare indeed if asked to lay aside for one moment that dignified carriage on which so much stress has been laid by the Master. Besides this, finger-nails an inch and a half long, guarded with an elaborate silver sheath, are decidedly *impedimenta* in the way of athletic success. No,—when the daily quantum of reading has been achieved, a Chinese student has very little to fall back upon in the way of amusement. He may take a stroll through the town and look in at the shops, or seek out some friend as *ennuyé* as himself, and while away an hour over a cup of tea and a pipe. Occasionally a number of young men will join together and form a kind of literary club, meeting at certain periods to read essays or poems on subjects previously agreed upon by all. We heard of one youth who, burning for the poet's laurel, produced the

* The first sentence of the Analects or Confucian Gospels.

following quatrain on *snow*, which had been chosen as the theme for the day :—

> The north-east wind blew clear and bright,
> Each hole was filled up smooth and flat :
> The black dog suddenly grew white,
> The white dog suddenly grew——

" And here," said the poet, " I broke down, not being able to get an appropriate rhyme to *flat.*" A wag who was present suggested *fat,* pointing out that the dog's increased bulk by the snow falling on his back fully justified the meaning, and, what is of equal importance in Chinese poetry, the antithesis.

Riddles and word-puzzles are largely used for the purpose of killing time, the nature of the written language offering unlimited facilities for the formation of the latter. Chinese riddles, by which term we include conundrums, charades, *et hoc genus omne,* are similar to our own, and occupy quite as large a space in the literature of the country. They are generally in doggerel, of which the following may be taken as a specimen, being like the last a word-for-word translation :—

> Little boy red-jacket, whither away ?
> To the house with the ivory portals I stray.
> Say will you come back, little red-coat, again ?
> My bones will return, but my flesh will remain.

In the present instance the answer is so plain that it is almost insulting to our readers to mention that it is " a cherry," but this is by no means the case with all Chinese riddles, many being exceedingly difficult of solution. So much so that it is customary all over the

Empire to copy out any particularly puzzling conundrum on a paper lantern, and hang it in the evening at the street door, with the promise of a reward to any comer who may succeed in unravelling it. These are called "lamp riddles," and usually turn upon the name of some tree, fruit, animal, or book, the direction in which the answer is to be sought being usually specified as a clue.

Were it only in such innocent pastimes as these that the Chinese indulged, we might praise the simplicity of their morals, and contrast them favourably with the excitement of European life. But there is just one more little solace for leisure, and too often business hours, of which we have not yet spoken. Gambling is, of course, the distraction to which we allude ; a vice ten times more prevalent than opium-smoking, and proportionately demoralising in its effect upon the national character. In private life, there is always some stake however small ; take it away, and to a Chinaman the object of playing any game goes too. In public, the very costermongers who hawk cakes and fruit about the streets are invariably provided with some means for determining by a resort to chance how much the purchaser shall have for his money. Here, it is a bamboo tube full of sticks, with numbers burnt into the concealed end, from which the customer draws ; at another stall dice are thrown into an earthenware bowl, and so on. Every hungry coolie would rather take his chance of getting nothing at all, with the prospect of perhaps obtaining

three times his money's worth, than buy a couple of
sausage-rolls and satisfy his appetite in the legitimate
way. The worst feature of gambling in China is the
number of hells opened publicly under the very nose
of the magistrate, all of which drive a flourishing
trade in spite of the frequent *presents* with which
they are obliged to conciliate the venal official whose
duty it is to put them down. To such an extent is
the system carried that any remissness on the part of
the keepers of these dens in conveying a reasonable
share of the profits to his honour's treasury, is met by
a brutum fulmen in the shape of a proclamation, set-
ting forth how "it having come to my ears that, re-
" gardless of law, and in the teeth of my frequent
" warnings, certain evil-disposed persons have dared
" to open public gambling-houses, be it hereby made
" known," &c., &c., the whole document being liberally
interspersed with allusions to the men of old, the laws
of the reigning dynasty, and filial piety *à discrétion*.
The upshot of this is that within twenty-four hours
after its appearance his honour's wrath is appeased,
and croupiers and gamblers go on in the same old
round as if nothing whatever had happened.

LAW,* as we understand the term, with all its para-
doxes and refinements, is utterly unknown to the
Chinese, and it was absolutely necessary to invent an
equivalent for the word "barrister," simply because no
such expression was to be found ready-made in the
language. Further, it would be quite impossible to
persuade even the most enlightened native that the
Bar is an honourable profession, and that its members
are men of the highest principles and integrity. They
cannot get it out of their heads that western lawyers
must belong to the same category as a certain dis-
reputable class among themselves, to be met with in
every Chinese town of importance, and generally re-
siding in the vicinity of a magistrate's or judge's
yamen. These fellows are always ready to undertake
for a small remuneration the conduct of cases, in so far
as they are able to do this by the preparation of skil-
fully-worded petitions or counter-petitions, and by
otherwise giving their advice. Of course they do not
appear in court, for their very existence is forbidden,
but their services are largely availed of by the people,
especially the poor and ignorant. At the trial, prose-

* Civil law.

cutor and accused must each manage his own case, the magistrate himself doing all the cross-examination. We say *prosecutor* and *accused* advisedly, for as a matter of fact civil cases are rare in China, such questions as arise in the way of trade being almost invariably referred to some leading guild, whose arbitration is accepted without appeal. Now, we know of no such book as " Laws of Evidence " in the whole range of Chinese literature ; yet we believe firmly that the intellects which adorn our own bench are not more keen in discriminating truth from falsehood, and detecting at a glance the corrupt witness, than the semi-civilised native functionary—that is, when no silver influences have been brought to bear upon his judgment. The Chinese have a penal code which, allowing for the difference in national customs and habits of thought, stands almost unrivalled ; and with this solitary work their legal literature begins and ends. It is regarded by the people as an inspired book, though few know much beyond the title, and seems to answer its purpose well.

But inasmuch as in China as elsewhere *summum jus* is not unfrequently *summa injuria,* a clever magistrate never hesitates to set aside law or custom, and deal out Solomonic justice with an unsparing hand, provided always he can shew that his course is one which *reason* infallibly dictates. Such an officer wins golden opinions from the people, and his departure from the neighbourhood is usually signalised by the presentation of the much-coveted testimonial umbrella. In the

reign of the last Emperor but one, less than twenty years ago, there was an official of this stamp employed as " second Prefect " in the department of Hanyang. Many and wonderful are the stories told of his unerring acumen, and his memory is still fondly cherished by all who knew him in his days of power. We will quote one from among numerous traditions of his genius which have survived to the present day.

A poor man, passing through one of the back thoroughfares in Hankow, came upon a Tls. 50* note lying in the road and payable to bearer. His first impulse was to cash it, but reflecting that the sum was large and that the loser might be driven in despair to commit suicide, the consequences of which might be that he himself would perhaps get into trouble, he determined to wait on the spot for the owner and rest content with the " thanks money " he was entitled by Chinese custom to claim as a right. Very shortly he saw a stranger approaching, with his eyes bent on the ground, evidently in search of something; whereupon he made up to him and asked at once if anything was the matter. Explanations followed, and the Tls. 50 note was restored to its lawful possessor, who, recovering himself instantaneously, asked where the other one was, and went on to say that he had lost *two* notes of the same value, and that on recovery of the other one he would reward the finder as he deserved, but that unless that also was forthcoming he should be too great a loser as it was. His benefactor was protesting

*· Fifty taels, equal to about £15.

strongly against this ungenerous behaviour when the " second Prefect " happened to come round the corner, who, seeing there was a row, stopped his chair, and inquired there and then into the merits of the case. The result was that he took the Tls. 50 note and presented it to the honest finder, telling him to go on his way rejoicing ; while, turning to the ungrateful loser, he sternly bade him wait till he met some one who had found *two* notes of that value, and from him endeavour to recover his lost property.

FROM the previous sketch it may readily be gathered that the state of Chinese law, both civil* and criminal, is a very important item in the sum of those obstacles which bar so effectually the admission of China—not into the cold and uncongenial atmosphere euphuistically known as the "comity of nations"—but into closer ties of international intercourse and friendship on a free and equal footing. For as long as we have ex-territorial rights, and are compelled to avail ourselves thereof, we can regard the Chinese nation only *de haut en bas;* while, on the other hand, our very presence under such, to them abnormal conditions, will continue to be neither more or less than a humiliating eye-sore. Till foreigners in China can look with confidence for an equitable administration of justice on the part of the mandarins, we fear that even science, with all its resources, will be powerless to do more than pave the way for that wished-for moment when China and the West will shake hands over all the defeats sustained by the one, and all the insults offered to the other.

It is in the happily unfrequent cases of homicide

* That is, local custom.

where a native and a foreigner play the principal parts, that certain discrepancies between Chinese and Western law, rules of procedure and evidence, besides several other minor points, stand out in the boldest and most irreconcilable relief. To begin with, the Penal Code and all its modifications of murder, answering in some respects to our distinction between murder and manslaughter, is but little known to the people at large. Nay, the very officials·who administer these laws are generally as grossly ignorant of them as it is possible to be, and in every judge's yamên in the Empire there are one or two "law experts," who are always prepared to give chapter and verse at a moment's notice, —in fact, to guide the judge in delivering a proper verdict, and one such as must meet with the approbation of his superiors. The people, on the other hand, know but one leading principle in cases of murder—a life for a life. Under extenuating circumstances cases of homicide are compromised frequently enough by money payments, but if the relatives should steadily refuse to forego their revenge, few officials would risk their own position by failing to fix the guilt somewhere. As a rule, it is not difficult to obtain the conviction and capital punishment of any native, or his substitute, who has murdered a foreigner, and we might succeed equally well in many instances of justifiable homicide or manslaughter : it is when the case is reversed that we call down upon our devoted heads all the indignation of the Celestial Empire. Of course any European who could be proved to have murdered

a native would be hanged for it; but he may kill him in self-defence or by accident, in both of which instances the Chinese would clamour for the extreme penalty of the law. Further, *hearsay* is evidence in a Chinese court of justice, and if several witnesses appeared who could only say that some one else told them that accused had committed the murder, it would go just as far to strangling or beheading him, as if they had said they saw the deed themselves. The accused is, moreover, not only allowed to criminate himself, but no case being complete without a full confession on the part of the guilty man, torture might be brought into play to extort from him the necessary acknowledgment. It is plain, therefore, that Chinese officials prosecuting on behalf of their injured countrymen, are quite at sea in an English court, and their case often falling through for want of proper evidence, they return home cursing the injustice done them by the hated barbarians, and longing for the day which will dawn upon their extermination from the Flowery Land.

On the other hand, the examination of Chinese witnesses, either in a civil or criminal case, is one of the most trying tests to which the forbearance of foreign officials is exposed in all the length and breadth of their intercourse with the slippery denizens of the middle kingdom. Leaving out of the question the extreme difficulty of the language, now gradually yielding to methodical and persevering study, the peculiar bent of the Chinese mind, with all its preju-

dices and superstitions, is quite as much an obstacle in the way of eliciting truth as any offered by the fantastic, but still amenable, varieties of Chinese syntax. We believe that native officials have the power, though it does not always harmonise with their interests to exercise it, of arriving at as just and equitable decisions in the majority of cases brought before them, as any English magistrate who knows " Taylor's Law of Evidence " from beginning to end. They accomplish this by a knowledge of character, unparalleled perhaps in any country on the globe, which enables them to distinguish readily, and without such constant recourse to torture as is generally supposed, between the false and honest witness. The study of mankind in China is, beyond all doubt—man and his motives for action on every possible occasion, and under every possible condition. Thus it is, we may remark, that the Chinese fail to appreciate the efforts made for their good by missionaries and others, because the motives for such a course are utterly beyond the reach of native investigation and thought. They are consequently suspicious of the Greeks—*et dona ferentes*. The self-denial of missionaries who come out to China to all the hardships of Oriental life—though, as a facetious writer in the *Shanghai Courier* lately remarked, they live in the best houses, and seem to lead as jolly lives as anybody else out here—to say nothing of gratuitous medical advice and the free distribution of all kinds of medicine—all this is entirely incomprehensible to the narrow mind of the calculating native.

Their observations have been confined to the characters and habits of thought which distinguish their fellow-countrymen, and with the result above-mentioned ; of the European mind they know absolutely nothing.

As regards the evidence of Chinese taken in a foreign court of justice, the first difficulty consists generally in swearing . the witnesses. Old books on China, which told great lies without much danger of conviction, mention cock-killing and saucer-breaking as among the most binding forms of Chinese oaths. The common formula, however, which we consider should be adopted in preference to any hybrid expression invented for the occasion, is an invocation to heaven and earth to listen to the statements about to be made, and to punish the witness for any deviation from the truth. This is sensible enough, and is moreover not without weight among a superstitious people like the Chinese. The witness then expects the magistrate to ask him the name of his native district, his own name, his age, the age of his father and mother (if alive), the maiden name of his wife, her age, the number and the ages of his children, and many more questions of similar relevancy and importance, before a single effort is made towards eliciting any one fact bearing upon the subject under investigation. With a stereotyped people like the Chinese, it does not do to ignore these trifles of form and custom; on the contrary, the witness should rather be allowed to wander at will through such useless details until he

has collected his scattered thoughts, and may be safely coaxed on to divulge something which partakes more of the nature of evidence. Under proper treatment, a Chinese witness is by no means doggedly stubborn or doltishly stupid ; he may be either or both if he has previously been tampered with by native officials, but even then it is not absolutely impossible to defeat his dishonesty. Occasionally a question will be put by a foreigner to an unsophisticated boor, never dreamt of in the philosophy of the latter, and such as would never have fallen from the lips of one of his own officials ; the answers given under such circumstances are usually unique of their kind. We know of an instance where a boatman was asked, in reference to a collision case, at what rate he thought the tide was running. The witness hesitated, looked up, down, on either side, and behind him; finally he replied :—" I am a poor boatman ; I only earn one hundred and fifty cash a day, and how can you expect me to know at what rate the tide was running ?"

THERE are few more loathsome types of character either in the East or West than the Buddhist priest of China. He is an object of contempt to the educated among his countrymen, not only as one who has shirked the cares and responsibilities to which all flesh is heir, but as a misguided outcast who has voluntarily resigned the glorious title and privileges of that divinely-gifted being represented by the symbol *man*. With his own hands he has severed the five sacred ties which distinguish him from the brute creation, in the hope of some day attaining what is to most Chinamen a very doubtful immortality. Paying no taxes and rendering no assistance in the administration of the Empire, his duty to his sovereign is incomplete. Marrying no wife, his affinity, the complement of his earthly existence, sinks into a virgin's grave. Rearing no children, his troubled spirit meets after death with the same neglect and the same absence of cherished rites which cast a shadow upon his parents' tomb. Renouncing all fraternal ties, he deprives himself of the consolation and support of a brother's love. Detaching himself from the world and its vanities, friendship spreads its charms for him in vain. Thus he

is in no Chinese sense a man. He has no name, and is frequently shocked by some western tyro in Chinese who, thinking to pay the everyday compliment bandied between Chinamen, asks to his intense disgust—" What is your honourable name ?" The unfortunate priest has substituted a " religious designation" for the patronymic he discarded when parents, brethren, home, and friends were cast into oblivion at the door of the temple.

But it is not on such mere sentimental grounds that the Chinese nation has condemned in this wholesale manner the clergy of China. Did the latter carry out even to a limited extent their vows of celibacy and Pythagorean principles of diet, they would probably obtain a fair share of that questionable respect which is meted out to enthusiasts in most countries on the globe. The Chinese hate them as doubledyed hypocrites who extort money from the poor and ignorant, work upon the fears of, and frequently corrupt, their wives or daughters; proclaim in bold characters at the gates of each temple—" no meat or wine may enter here "—while all the time they dine off their favourite pork as often as most Chinamen, and smoke or drink themselves into a state of beastly intoxication a great deal more so. Opium pipes are to be found as frequently as not among the effects of these sainted men, who, with all the abundant leisure at their command, are rarely of sufficient education to be mentioned in the same breath with an ordinary graduate. Occasionally there have been exceptions

to the rule, but the phenomenon is seldom met with in modern times. We have read of a lame old priest so renowned for self-denying liberality that the great Emperor Ch'ien Lung actually paid him a visit. After some conversation Ch'ien Lung presented him with a valuable pearl, which the old man immediately bestowed upon a beggar he espied among the crowd. His Majesty was somewhat taken aback at this act of rudeness, and asked him if he always gave away everything in the same manner. On receiving an affirmative reply, the Emperor added, "Even down to the crutch on which you lean?" "Ah," said the priest, "it is written that the superior man does not covet what his friend cannot spare." "But supposing," said the Emperor, "he was not a superior man." "In that case," answered the priest, "you could not expect me to be his friend."

Cleanliness, again, is an especial attribute of Buddhism, and in a few temples in the south there is an attempt to make some show in this direction; but as regards the person, priests are dirtier if anything than the humblest members of their flock. It is laughable indeed to hear them chant the *Ching,* ignorant as ninety-nine per cent. are of every word they are saying, for of late years the study of Sanskrit has been utterly and entirely neglected. Their duties, however, in this respect are as much curtailed as possible, except when wafting with their prayers some spirit of the dead to the realms of bliss above. In such cases it is a matter of business, a question of

money; and the unctious air of solemn faith they then put on contrasts curiously with the bored and sleepy look apparent on their faces as they gabble through a midnight mass, in the presence of some such limited and unimportant audience as a single and perhaps a red-haired barbarian.

It is pleasant to dismiss from our thoughts this lying, shameless, debauched class; and we do so, wondering how Buddhism has retained its hold so long over an intellectual people possessed of an elaborate moral code, which has been for centuries the acknowledged standard of right and wrong, and which condemns all fear or hope of an unknown and unseen world.

ONE of the most curious and harmless customs of the Chinese is that of carefully burning every scrap of paper inscribed with the cherished characters which, as far as calligraphy goes, justly take precedence of those of any other language on the globe. Not content with mere reduction by fire, a conscientious Chinaman will collect the ashes thus produced, and sealing them up in some earthen vessel, will bury them deep in the earth or sink them to the bottom of a river. Then only does he consider that he has fully discharged his duty towards paper which has by mere accident become as sacred in the eyes of all good men as the most precious relic of any martyred saint in the estimation of a Catholic priest. Rich men are constantly in the habit of paying *chiffoniers* to collect such remnants of written paper as they may find lying about the streets, and in all Chinese towns there are receptacles at the most frequented points where the results of their labours may be burned. The above facts are pretty generally known to foreigners in China and elsewhere, but we do not think that native ideas on the subject have ever been brought forward otherwise than indirectly. We therefore give the

translation of a short essay published in 1870 by an enthusiastic scholar, and distributed gratis among his erring countrymen :—

" From of old down to the present time our sages have devoted themselves to the written character—that fairest jewel in heaven above or earth beneath. Those, therefore, who are stimulated by a thirst for *fame*, strive to attain their end by the excellency of their compositions ; others, attracted by desire for wealth, pursue their object with the help of day-books and ledgers. In both cases men would be helpless without a knowledge of the art of writing. How, indeed, could despatches be composed, agreements drawn up, letters exchanged, and genealogies recorded, but for the assistance of the written character ? By what means would a man chronicle the glory of his ancestors, indite the marriage deed, or comfort anxious parents when exiled to a distant land ? In what way could he secure property to his sons and grandchildren, borrow or lend money, enter into partnership, or divide a patrimony, but with the testimony of written documents ? The very labourer in the fields, tenant of a few acres, must have his rights guaranteed in black and white ; and household servants require more than verbal assurance that their wages will not fail to be paid. The prescription of the physician, about to call back some suffering patient from the gates of death, is taken down with pen and ink; and the prognostication of the sooth-sayer, warning men of evil or predicting good fortune, exemplifies in another direction the use of the written character. In a word, the art of writing enriches and ennobles man, hands him over to life or death, confers upon him honours and distinctions, or covers him with abuse and shame.

" Of late, however, our schools have turned out an arrogant and ignorant lot—boys who venture to use old books for wrapping parcels or papering windows, for boiling water, or wiping the table ; boys, I say, who scribble over their books, who write characters on wall or door, who chew up the drafts of their poems, or throw them away on the ground. Let all such be severely punished by their masters that they may be saved, while there is yet time, from the wrath of an avenging Heaven. Some men use old pawn-tickets for wrapping up things—it may be a cabbage or a pound of bean-

curd. Others use lottery-tickets of various descriptions for wrapping up a pickled vegetable or a slice of pork, with no thought of the crime they are committing as long as there is a cash to be made or saved. So also there are those who exchange their old books for pumeloes or ground-nuts, to be defiled with the filth of the waste-paper basket, and passed from hand to hand like the cheques of the barbarian. Alas, too, for women when they go to fairs, for children who are sent to market! They cannot read one single character: they know not the priceless value of written paper. They drop the wrapping of a parcel in the mire for every passer-by to tread under foot. Their crime, however, will be laid at the door of those who erred in the first instance (*i.e.*, those who sold their old books to the shopkeepers). For they hoped to squeeze some profit, infinitesimal indeed, out of tattered or incomplete volumes; forgetting in their greed that they were dishonouring the sages, and laying up for themselves certain calamity. Why then sacrifice so much for such trifling gain? How much better a due observance of time-honoured custom, ensuring as it would a flow of prosperity continuous and everlasting as the waves of the eastern sea! O ye merchants and shopkeepers, know that in heaven as on earth written words are esteemed precious as the jade, and whatever is marked therewith must not be cast aside like stones and tiles. For happiness, wealth, honours, distinctions, and old age, may be one and all secured by a proper respect for written paper."

EDUCATED Chinamen loudly disclaim any participation in the superstitious beliefs which, to a European eye, hang like a dark cloud over an otherwise intellectually free people. There never has been a State religion in China, and it has always been open to every man to believe and practise as much or as little as he likes of Buddhism, Taoism, or Mahomedanism, without legal interference or social stigma of any kind. Of course it is understood that such observances must be purely self-regarding, and that directly they assume—as lately in the case of Mahomedanism—anything of a political character, the Chinese Government is not slow to protect the unity of the Empire by the best means in its power. And so, but for the suicidal zeal of Christian missions and their supporters, who have effected an unnatural amalgamation of religion and politics, and carried the Bible into China at the point of the bayonet, the same toleration might now be accorded to Christianity which the propagators of other religions have hitherto been permitted to enjoy.

As to religion in China, it is only of the ethics of Confucius that the State takes any real cognizance. His is what John Stuart Mill alluded to as " the best

wisdom they possess;" and, as he further observed,
the Chinese have secured " that those who have appro-
priated most of it shall occupy the posts of honour and
power." His maxims are entirely devoid of the super-
stitious element. He recognises a principle of right
beyond the ken of man ; but though he once said that
this principle was conscious of his existence and his
work on earth, it never entered his head to endow it
with anything like retributory powers. Allusions to
an unseen world were received by him with scorn ;
and as regards a future state, he has preserved a most
discreet silence. " While you do not know life, how
can you know about death ?" was the rebuke he
administered to a disciple who urged some utterance
on the problem of most interest to mankind. And
yet, in spite of the extreme healthiness of Confucian
ethics, there has grown up, around both the political
and social life of the Chinese, such a tangled maze of
superstition, that it is no wonder if all intellectual
advancement has been first checked, and has then
utterly succumbed. The ruling classes have availed
themselves of its irresistible power to give them a
firmer hold over their simple-hearted, credulous sub-
jects ; they have practised it in its grossest forms, and
have written volumes in support of absurdities in
which they cannot really have the slightest faith them-
selves. It was only a year or two ago that the most
powerful man in China, a distinguished scholar, states-
man, and general, prostrated himself before a diminu-
tive water-snake, in the hope that by humble inter-

cession with the God of Floods he might bring about a respite from the cruel miseries which had been caused by inundations over a wide area of the province of Chihli. The suppliant was no other than the celebrated Viceroy, Li Hung-chang, who has recently armed the forts at the mouth and on the banks of the Peiho with Krupp's best guns, instead of trusting, as would be consistent, the issue of a future war to the supernatural efforts of some Chinese Mars.

Turning now to the literature of China, we cannot but be astonished at the mass of novels which are one and all of the same tendency; in fact, not only throughout the entire stratum of Chinese fiction, but even in that of the gravest philosophical speculations, has the miraculous been introduced as a natural and necessary element. The following passage, taken from the writings of Han Wên-kung, whose name has been pronounced to be "one of the most venerated," is a fair specimen of the trash to be met with at every turn in that trackless, treeless desert, which for want of a more appropriate term we are obliged to call the literature of China :—

"There are some things which possess form but are devoid of sound, as for instance jade and stones; others have sound but are without form, such as wind and thunder; others again have both form and sound, such as men and animals; and lastly, there is a class devoid of both, namely, *devils and spirits.*"

Descending to the harmless superstitions of domestic life, we find that the cat washing her face is not,

as with us, a sign of rain, but that a stranger is coming. On the other hand, "strangers" in tea portend, as with us, the arrival of some unlooked-for guest, tall or short, fat or lean, according to the relative proportions of the prophetic twig. Aching corns denote the approach of wet weather—we do not quote this as a superstition—and for a girl to spill water on fowls or dogs will ensure a downpour of rain on her weddingday. Any one who hears a crow caw should chatter his teeth three times and blow; and two brooms together will bring joy and sorrow at the same time, as a birth and a death on the same day. "Crows' feet" on the face are called "fishes' tails," and in young men mean what the widower's peak is supposed to signify with us.

Superstition is China's worst enemy—a shadow which only the pure light of science will be able to dispel. There are many amongst us who would give her more : but they will not succeed.

IT is a question of more than ordinary interest to those who regard the Chinese people as a worthy object of study, What are the speculations of the working and uneducated classes concerning such natural phenomena as it is quite impossible for them to ignore? Their theory of eclipses is well known, foreign ears being periodically stunned by the gonging of an excited crowd of natives, who are endeavouring with hideous noises to prevent some imaginary dog of colossal proportions from banqueting, as the case may be, upon the sun or moon. At such laughable exhibitions of native ignorance it will be observed that there is always a fair sprinkling of well-to-do, educated persons, who not only ought to know better themselves, but should be making some effort to enlighten their less fortunate countrymen instead of joining in the din. Such a hold, however, has superstition on the minds of the best informed in a Chinese community, that under the influence of any real or supposed danger, philosophy and Confucius are scattered to the four winds of heaven, and the proudest disciple of the Master proves himself after all but a man.

Leaving the literati to take care of themselves, and confining our attention to the good-tempered, joyous, hospitable working-classes of China, we find many curious beliefs on subjects familiar among western nations to every national school-boy. The earth, for instance, is popularly believed to be square ; and the heavens a kind of shell or covering, studded with stars and revolving round the earth. We remember once when out of sight of land calling the notice of our native valet to the masts of a vessel sinking below the horizon. We pointed out to him that were the earth a perfectly flat surface its disappearance would not be so comparatively sudden, nor would the ship appear to sink. But at the last moment, when we felt that conviction was entering into his soul and that another convert had been made to the great cause of scientific truth, he calmly replied that it was written—" Heaven is round, earth is square," and he didn't very well understand how books could be wrong !

The sun is generally supposed to pass at sunset into the earth, and to come out next morning at the other side. The moon is supposed to rise from and set in the ocean. Earthquakes are held to result from explosions of sulphur in the heart of the earth ; rain is said to be poured down by the Dragon God who usually resides on the other side of the clouds, and the rainbow is believed to be formed by the breath of an enormous oyster which lives somewhere in the middle of the sea, far away from land. Comets and eclipses

of the sun are looked upon as special warnings to the throne, and it is usual for some distinguished censor to memorialise the Emperor accordingly. The most curious perhaps of all these popular superstitions are those which refer to thunder, lightning, and hail, regarded in China as the visitation of an angry and offended god. In the first place it is supposed that people are struck by thunder and not by lightning—a belief which was probably once prevalent in England, as evidenced by the English word *thunderstruck.* Sir Philip Sydney writes :—" I remained as a man thunder-stricken." Secondly, death by thunder is regarded as a punishment for some secret crime committed against human or divine law, and consequently a man who is not conscious of anything of the kind faces the elements without fear. Away behind the clouds during a storm or typhoon sit the God of Thunder armed with his terrible bolts, and the Goddess of Lightning, holding in her hand a dazzling mirror. With this last she throws a flash of lightning over the guilty man that the God of Thunder may see to strike his victim; the pealing crash which follows is caused by the passage through the air of the invisible shaft—and the wrongs of Heaven are avenged. Similarly, hail is looked upon as an instrument of punishment in the hands of the Hail God, directed only against the crops and possessions of such mortals as have by their wicked actions exposed themselves to the slow but certain visitation of divine vengeance.

Each province, nay, each town, has its own particular set of superstitions on a variety of subjects; the above, however, dealing with the most important of all natural phenomena, will be found common to every village and household in the Chinese Empire. The childlike faith with which such quaint notions are accepted by the people at large is only equalled by the untiring care with which they are fostered by the ruling classes, who are well aware of their value in the government of an excitable people. The Emperor himself prays loud and long for rain, fine weather, or snow, according as either may be needed by the suffering crops, and never leaves off until the elements answer his prayers. But here we are ridiculing a phase of superstition from which nations with greater advantages than China are not yet wholly free.

CHINA New Year!—What a suggestive ring have those three words for "the foreigner in far Cathay."* What visions do they conjure up of ill-served tiffins, of wages forestalled, of petty thefts and perhaps a burglary; what thoughts of horrid tom-toms and ruthless fire-crackers, making day hideous as well as night; what apparitions of gaudily-dressed butlers and smug-faced coolies, their rear brought up by man's natural enemy in China—the cook, for once in his life clean, and holding in approved Confucian style † some poisonous indigestible present he calls a cake !

New Year's Day is the one great annual event in Chinese social and political life. An Imperial birthday, even an Imperial marriage, pales before the important hour at which all sublunary affairs are supposed to start afresh, every account balanced and every debt paid. About ten days previously the administration of public business is nominally suspended ; offices are closed, official seals carefully wrapped up and given into the safe keeping of His

* The title of Mr Medhurst's work.

† " In presenting gifts, his countenance wore a placid appearance."—Analects : ch. x.

Honour's or His Excellency's wife.* The holidays last one month, and during that time inaction is the order of the day, it being forbidden to punish criminals, or even to stamp, and consequently to write, a despatch on any subject whatever. The dangerous results, however, that might ensue from a too literal observance of the latter prohibition are neatly anticipated by stamping beforehand a number of blank sheets of paper, so that, if occasion requires, a communication may be forwarded without delay and without committing an actual breach of law or custom.

The New Year is the season of presents. Closely-packed boxes of Chinese cake, biscuits, and crystal-lised fruit, are presented as tributes of respect to the patriarchs of the family ; grapes from Shansi or Shantung, hams from Foochow, and lichees from Canton, all form fitting vehicles for a declaration of friendship or of love. Now, too, the birthday gifts offered by every official in the Empire to his immediate superior, are supplemented by further propitiatory sacrifices to the powers that be, without which tenure of office would be at once troublesome and insecure. Such are known as *dry*, in contradistinction to the *water* presents exchanged between relatives and friends. The latter are wholly, or at any rate in part, articles of food prized among the Chinese for their delicacy or rarity, perhaps both ; and so to all appearance are the baskets of choice oranges, &c., sent for instance by a

* A universal custom which may be quoted with countless others against the degradation-of-women-in-China doctrine.

District Magistrate with compliments of the season to
His Excellency the Provincial Judge. But the Magistrate and the Judge know better, for beneath that
smiling fruit lie concealed certain bank-notes or shoes
of silver of unimpeachable touch, which form a unit
in the sum of that functionary's income, and enable
him in his turn to ingratiate himself with the all-
powerful Viceroy, while he lays by from year to year a
comfortable provision against the time when sickness
or old age may compel him to resign both the duties
and privileges of government.

To "all between the four seas," patrician and ple-
beian* alike, the New Year is a period of much inten-
sity. On the 23d or 24th of the preceding moon it is
the duty of every family to bid farewell to the Spirit
of the Hearth, and to return thanks for the protection
vouchsafed during the past year to each member of
the household. The Spirit is about to make his annual
journey to heaven, and lest aught of the disclosures he
might make should entail unpleasant consequences, it
is adjudged best that he shall be rendered incapable
of making any disclosures at all. With this view,
quantities of a very sticky sweetmeat are prepared
and presented as it were in sacrifice, on eating which
the unwary god finds his lips tightly glued together,
and himself unable to utter a single syllable. Beans
are also offered as fodder for the horse on which he is
supposed to ride. On the last day of the old year he

* Chinese society is divided into two classes—officials and non-
officials.

returns and is regaled to his heart's content on brown sugar and vegetables. That is the time *par excellence* for cracker-firing, though, as everybody knows, these abominations begin some days previously. Every one, however, may not be aware that the object of letting off these crackers is to rid the place of all the evil spirits that may have collected together during the twelve months just over, so that the influences of the young year may be uncontaminated by their presence. New Year's eve is no season for sleep : in fact, China-men almost think it obligatory on a respectable son of Han to sit up all night. Indeed, unless his bills are paid, he would have a poor chance of sleeping even if he wished. His persevering creditor would not leave his side, but would sit there threatening and pleading by turns until he got his money or effected a compromise. Even should it be past twelve o'clock, the wretched debtor cannot call it New Year's Day until his unwelcome dun has made it so by blowing out the candle in his lantern. Of course there are exceptions, but as a rule all accounts in China are squared up before the old year has become a matter of history and the new year reigns in its stead. Then, with the first streaks of dawn, begins that incessant round of visits which is such a distinguishing feature of the whole proceedings. Dressed out in his very best, official hat and boots, button and peacock's feather, if lucky enough to possess them,* every indi-vidual Chinaman in the Empire goes off to call on all

* No matter whether by merit or by purchase.

his relatives and friends. With a thick wad of cards, he presents himself first at the houses of the elder branches of the family, or visits the friends of his father; when all the seniors have been disposed of, he seeks out his own particular cronies, of his own age and standing. If in the service of his country, he does not omit to call at the yamen and leave some trifling souvenir of his visit for the officer immediately in authority over him. Wherever he goes he is always offered something to eat, a fresh supply of cakes, fruit, and wine, being brought in for each guest as he arrives. While thus engaged his father, or perhaps brother, will be doing the honours at home, ready to take their turn as occasion may serve. "New joy, new joy; get rich, get rich," is the equivalent of our "Happy New Year," and is bandied about from mouth to mouth at this festive season, until petty distinctions of nationality and creed vanish before the conviction that, at least in matters of sentiment, Chinamen and Europeans meet upon common ground. Yet there is one solitary exception to the rule—an unfortunate being whom no one wishes to see prosperous, and whom nobody greets with the pleasant phrase, "Get rich, get rich." It is the coffin-maker.

A GREAT Chinese festival is the Feast of Lanterns, one which is only second in importance to New Year's Day. Its name is not unfamiliar even to persons in England who have never visited China, and whose ideas about the country are limited to a confused jumble of pigtails, birds'-nest soup, and the *kotow*. Its advent may or may not be noticed by residents in China ; though if they know the date on which it falls, we imagine that is about as much as is generally known by foreigners of the Feast of Lanterns.

This festival dates from the time of the Han dynasty, or, in round numbers, about two thousand years ago. Originally it was a ceremonial worship in the temple of the First Cause, and lasted from the 13th to the 16th of the first moon, bringing to a close on the latter date all the rejoicings, feastings, and visitings consequent upon the New Year. In those early days it had no claim to its present title, for lanterns were not used ; pious supplicants performed their various acts of prayer and sacrifice by the light of the full round moon alone. It was not till some eight hundred years later that art came to the assistance of nature, and the custom was introduced of illu-

minating the streets with many a festoon of those gaudy paper lanterns, without which now no nocturnal fête is thought complete. Another three hundred years passed away without change, and then two more days were added to the duration of the carnival, making it six days in all. For this it was necessary to obtain the Imperial sanction, and such was ultimately granted to a man named Ch'ien, in consideration of an equivalent which, as history hints, might be very readily expressed in taels. The whole thing now lasts from the 13th of the moon, the day on which it is customary to light up for the first time, to the 18th inclusive, when all the fun and jollity is over and the serious business of life begins anew. The 15th is the great time, work of every kind being as entirely suspended as it is with us on Christmas Day. At night the candles are lighted in the lanterns, and crackers are fired in every direction. The streets are thronged with gaping crowds, and cut-purses make small fortunes with little or no trouble. There being no policemen in a Chinese mob, and as the cry of "stop thief" would meet with no response from the bystanders, a thief has simply to look out for some simple victim, snatch perhaps his pipe from his hand, or his pouch from his girdle, and elbow his way off as fast as he can go.

Plenty of lights and plenty of joss-stick would be enough of themselves to make up a festival for Chinamen; in the present instance there should be an extra abundance of both, though for reasons not generally

known to uneducated natives. Ask a coolie why he
lights candles and burns joss-stick at the Feast of
Lanterns, and he will probably be unable to reply.
The idea is that the spirits of one's ancestors choose
this occasion to come back *dulces revisere natos,* and,
that in their honour the hearth should be somewhat
more swept and garnished than usual. Therefore they
consume bundle upon bundle of well-scented joss-
stick, that the noses of the spirits may run no risk of
being offended by mundane smells. Candles are
lighted, that these disembodied beings may be able
to see their way about; and their sense of the beau-
tiful is consulted by a tasteful arrangement of the
pretty lamps in which the dirty Chinese dips are con-
cealed. Worship on this occasion is tolerably pro-
miscuous; the Spirit of the Hearth generally comes
in for his share, and Heaven and Earth are seldom left
out in the cold. One very important part of the fun
consists in eating largely of a kind of cake prepared
especially for the occasion. Sugar, or some sweet
mince-meat, is wrapped up in snow-white rice flour
until about the size of a small hen's egg, only per-
fectly round, and these are eaten by hundreds in every
household. Their shape is typical of a complete
family gathering, for every Chinaman makes an effort
to spend the Feast of Lanterns at home.

Under the mournful circumstances of the late
Emperor's death, the 15th of the 1st Chinese moon
was this year (1875) hardly distinguishable from any
other day since the rod of empire passed from the

hands of a boy to those of a baby. No festivities were possible ; it was of course unlawful to hang lamps in any profusion, and all Chinamen have been prohibited by Imperial edict from wearing their best clothes. The utmost any one could do in the way of enjoyment was to gorge himself with the rice-flour balls above-mentioned, and look forward to gayer times when the days of mourning shall be over.

MANY writers on Chinese topics delight to dwell upon the slow but sure destruction of morals, manners, and men, which is being gradually effected throughout the Empire by the terrible agency of opium. Harrowing pictures are drawn of once well-to-do and happy districts which have been reduced to know the miseries of disease and poverty by indulgence in the fatal drug. The plague itself could not decimate so quickly, or war leave half the desolation in its track, as we are told is the immediate result of forgetting for a few short moments the cares of life in the enjoyment of a pipe of opium. To such an extent is this language used, that strangers arriving in China expect to see nothing less than the stern reality of all the horrors they have heard described; and they are astonished at the busy, noisy sight of a Chinese town, the contented, peaceful look of China's villagers, and the rich crops which are so readily yielded to her husbandmen by many an acre of incomparable soil. Where, then, is this scourge of which men speak? Evidently not in the highways, the haunts of commerce, or in the quiet repose of far-off agricultural hamlets. Bent on search, and pro-

bably determined to discover something, our seeker
after truth is finally conducted to an opium den,
one of those miserable hells upon earth common
to every large city on the globe. Here he beholds
the vice in all its hideousness; the gambler, the
thief, the beggar, and such outcasts from the social
circle, meet here to worship the god who grants
a short nepenthe from suffering and woe. This,
then, is China, and . travellers' tales are but too
true. A great nation has fallen a prey to the in-
sidious drug, and her utter annihilation is but an
affair of time !

We confess, however, we have looked for these signs
in vain ; but our patience has been rewarded by the
elucidation of facts which have led us to brighter con-
clusions than those so generally accepted. We have
not judged China as a nation from the inspection of a
few low opium-shops, or from the half dozen extreme
cases of which we may have been personally cognisant,
or which we may have gleaned from the reports of
medical missionaries in charge of hospitals for native
patients. We do not deny that opium is a curse, in
so far as a large number of persons would be better
without it ; but comparing its use as a stimulant with
that of alcoholic liquors in the West, we are bound to
admit that the comparison is very much to the dis-
advantage of the latter. Where opium kills its hun-
dreds, gin counts its victims by thousands ; and the
appalling scenes of drunkenness so common to a Euro-
pean city are of the rarest occurrence in China. In a

H

country where the power of corporal punishments is
placed by law in the hands of the husband, wife-beat-
ing is unknown; and in a country where an ardent
spirit can be supplied to the people at a low price, *deli-
rium tremens* is an untranslateable term. Who ever
sees in China a tipsy man reeling about a crowded
thoroughfare, or lying with his head in a ditch
by the side of some country road? The Chinese
people are naturally sober, peaceful, and industrious;
they fly from intoxicating, quarrelsome samshoo, to
the more congenial opium-pipe, which soothes the
weary brain, induces sleep, and invigorates the tired
body.

In point of fact, we have failed to find but a tithe
of that real vice which cuts short so many brilliant
careers among men who, with all the advantages of
education and refinement, are euphemistically spoken
of as addicted to the habit of " lifting their little
fingers." Few Chinamen seem really to love wine,
and opium, by its very price, is beyond the reach of
the blue-coated masses. In some parts, especially in
Formosa, a great quantity is smoked by the well-paid
chair-coolies, to enable them to perform the prodigies
of endurance so often required of them. Two of these
fellows will carry an ordinary Chinaman, with his box
of clothes, thirty miles in from eight to ten hours on
the hottest days in summer. They travel between
five and six miles an hour, and on coming to a stage,
pass without a moment's delay to the place where food
and opium are awaiting their arrival. After smoking

their allowance and snatching as much rest as the traveller will permit, they start once more upon the road; and the occupant of the chair cannot fail to perceive the lightness and elasticity of their tread, as compared with the dull, tired gait of half an hour before. They die early, of course; but we have trades in civilised England in which a man thirty-six years of age is pointed at as a patriarch.

It is also commonly stated that a man who has once begun opium can never leave it off. This is an entire fallacy. There is a certain point up to which a smoker may go with impunity, and beyond which he becomes a lost man in so far as he is unable ever to give up the practice. Chinamen ask if an opium-smoker has the *yin* or not; meaning thereby, has he gradually increased his doses of opium until he has established a *craving* for the drug, or is he still a free man to give it up without endangering his health. Hundreds and thousands stop short of the *yin;* a few, leaving it far behind them in their suicidal career, hurry on to premature old age and death. Further, from one point of view, opium-smoking is a more self-regarding vice than drunkenness, which entails gout and other evils upon the third and fourth generation. Posterity can suffer little or nothing at the hands of the opium-smoker, for to the inveterate smoker all chance of posterity is denied. This very important result will always act as an efficient check upon an inordinately extensive use of the drug in China, where children are regarded as the greatest

treasures life has to give, and blessed is he that has his quiver full.

Indulgence in opium is, moreover, supposed to blunt the moral feelings of those who indulge ; and to a certain extent this is true. If your servant smokes opium, dismiss him with as little compunction as you would a drunken coachman ; for he can no longer be trusted. His wages being probably insufficient to supply him with his pipe and leave a balance for family expenses, he will be driven to squeeze more than usual, and probably to steal. But to get rid of a writer or a clerk merely because he is a smoker, however moderate, would be much the same as dismissing an employé for the heinous offence of drinking two glasses of beer and a glass of sherry at his dinner-time. An opium-smoker may be a man of exemplary habits, never even fuddled, still less stupified. He may take his pipe because he likes it, or because it agrees with him ; but it does not follow that he must necessarily make himself, even for the time being, incapable of doing business. Wine and moonlight were formerly considered indispensables by Chinese bards ; without them, no inspiration, no poetic fire. The modern poetaster who pens a chaste ode to his mistress's eyebrow, seeks in the opium-pipe that flow of burning thoughts which his forefathers drained from the wine-cup. We cannot see that he does wrong. We believe firmly that a moderate use of the drug is attended with no dangerous results ; and that moderation in all kinds of eating, drinking, and smoking, is just as

common a virtue in China as in England or any-
where else.*

* Sir Edmund Hornby, after nine years' service as chief judge of the
Supreme Court at Shanghai, delivered an opinion on the anti-opium
movement in the following remarkable terms :—" Of all the nonsense
that is talked, there is none greater than that talked here and in England
about the immorality and impiety of the opium trade. It is simply
sickening. I have no sympathy with it, neither have I any sympathy
with the owner of a gin-palace ; but as long as China permits the growth
of opium throughout the length and breadth of the land, taxes it, and
pockets a large revenue from it,—sympathy with her on the subject is
simply ludicrous and misplaced."—(J. W. Walker *v.* Malcolm, 28th April
1875.)

But the following extract from a letter to the *London and China
Express*, of 5th July 1875, part of which we have ventured to reproduce
in italics, surpasses, both in fiction and *naiveté*, anything it has ever
been our lot to read on either side of this much-vexed question :—
" The fact is, that this tremendous evil is utterly beyond the control
of politicians, or even philanthropists. Nothing but the divine power
of Christian life can cope with it, and though this process may be slow,
it is sure. Christian missions alone can deal with the opium traffic, now
that it has attained such gigantic dimensions, and the despised mission-
aries are solving a problem which to statesmen is insoluble. Those,
therefore, who recognise the evils of opium-smoking will most effectually
stay the plague *by supporting Christian Protestant Missions in China.*—
Yours faithfully, AN OLD RESIDENTER IN CHINA.

" LONDON, *June* 28, 1875."

NOWHERE can the monotony of exile be more advantageously relieved by studying dense masses of humanity under novel aspects than in China, where so much is still unknown, and where the bulk of that which is generally looked upon as fact requires in most cases a leavening element of truth, in others nothing more nor less than flat contradiction. The days are gone by for entertaining romances published as if they were *bonâ fide* books of travel, and the opening of China has enabled residents to smile at the audacity of the too mendacious Huc. It has enabled them at the same time to view millions of human beings working out the problem of existence under conditions which by many persons in England are deemed to be totally incompatible with the happiness of the human race. They behold all classes in China labouring seven days in every week, taking holidays as each may consider expedient with regard both to health and means, but without the mental and physical demoralisation supposed to be inseparable from a non-observance of the fourth commandment. They see the unrestricted sale of spirituous liquors, unaccompanied by the scenes of

brutality and violence which form such a striking contrast to the intellectual advancement of our age. They notice that charity has no place among the virtues of the people, and that nobody gives away a cent he could possibly manage to keep ; the apparent result being that every one recognises the necessity of working for himself, and that the mendicants of a large Chinese city would barely fill the casual ward of one of our smallest workhouses. They have a chance of studying a competitive system many hundred years old, with the certainty of concluding that, whatever may be its fate in England or elsewhere, it secures for the government of China the best qualified and most intelligent men. Amongst other points, the alleged thievishness of the Chinese is well worth a few moments' consideration, were it only out of justice to the victims of what we personally consider to be a very mischievous assertion. For it is a not uncommon saying, even among Europeans who have lived in China, that the Chinese are a nation of thieves. In Australia, in California, and in India, Chinamen have beaten their more luxurious rivals by the noiseless but irresistible competition of temperance, industry, and thrift : yet they are a nation of thieves. It becomes then an interesting question how far a low tone of morality on such an important point is compatible with the undisputed practice of virtues which have made the fortunes of so many emigrating Celestials. Now, as regards the amount of theft daily perpetrated in China, we have been able to form a rough estimate,

by very careful inquiries, as to the number of cases
brought periodically before the notice of a district
magistrate or his deputies, and we have come to a
conclusion unfavourable in the extreme to western
civilisation, which has not hesitated to dub China a
nation of thieves. We have taken into consideration
the fact that many petty cases never come into court
in China, which, had the offence been committed in
England, would assuredly have been brought to the
notice of a magistrate. We have not forgotten that
more robberies are probably effected in China without
detection than in a country where the police is a well-
organised force, and detectives trained men and keen.
We know that in China many cases of theft are com-
promised, by the stolen property being restored to its
owner on payment of a certain sum, which is fixed
and shared in by the native constable who acts as
middleman between the two parties, and we are fully
aware that under circumstances of hunger or famine,
and within due limits, the abstraction of anything in
the shape of food is not considered theft. With all
these considerations in mind, our statistics (save the
mark !) would still compare most favourably with the
records of theft committed over an area in England
equal in size and population to that whence our infor-
mation was derived. The above refers specially to
professional practice, but when we descend to private
life, and view with an impartial eye the pilfering
propensities of servants in China, we shall have
even less cause to rejoice over our boasted morality

and civilisation. In the first place, squeezing of masters by servants is a recognised system among the Chinese, and is never looked upon in the light of robbery. It is *commission* on the purchase of goods, and is taken into consideration by the servant when seeking a new situation. Wages are in consequence low; sometimes, as in the case of official runners and constables, servants have to make their living as best they can out of the various litigants, very often taking bribes from both parties. As far as slight raids upon wine, handkerchiefs, English bacon, or other such luxuries dear to the heart of the Celestial, we might ask any one who has ever kept house in England if pilfering is quite unknown among servants there. If it were strictly true that Chinamen are such thieves as we make them out to be, with our eastern habits of carelessness and dependence, life in China would be next to impossible. As it is, people hire servants of whom they know absolutely nothing, put them in charge of a whole house many rooms in which are full of tempting kickshaws, go away for a trip to a port five or six hundred miles distant, and come back to find everything in its place down to the most utter trifles. Merchants as a rule have their servants *secured* by some substantial man, but many do not take this precaution, for an honest Chinaman usually carries his integrity written in his face. Confucius gave a wise piece of advice when he said, "If you employ a man, be not suspicious of him ; if you are suspicious of a man, do not employ him "—and truly foreigners in China seem

to carry out the first half to an almost absurd degree, placing the most unbounded confidence in natives with whose antecedents they are almost always un-acquainted, and whose very names in nine cases out of ten they actually do not know ! And what is the result of all this ? A few cash extra charged as commission on anything purchased at shop or market, and a steady consumption of about four dozen pocket-handkerchiefs per annum. Thefts there are, and always will be, in China as elsewhere ; but there are no better grounds for believing that the Chinese are a nation of thieves than that their own tradition is literally true which says, " In the glorious days of old, if anything was seen lying in the road, nobody would pick it up !" On the contrary, we believe that theft is not one whit more common in China than it is in England ; and we are fully convinced that the imputation of being a nation of thieves has been cast, with many others, upon the Chinese by unscrupulous persons whose business it is to show that China will never advance without the renovating influence of Christianity—an opinion from which we here express our most unqualified dissent.

WE have stated our conviction that the Chinese as a nation are not more addicted to thieving than the inhabitants of many countries for whom the same excuses are by no means so available. That no undiscerning persons may be led to regard us as panegyrists of a stationary civilisation, we hasten to counterbalance our somewhat laudatory statements by the enunciation of another proposition less startling, but if anything more literally true. *The Chinese are a nation of liars.* If innate ideas were possible, the idea of lying would form the foundation-stone of the Chinese mind. They lie by instinct; at any rate, they lie from imitation, and improve their powers in this respect by the most assiduous practice. They seem to prefer lying to speaking the truth, even when there is no stake at issue; and as for shame at being found out, the very feeling is unfamiliar to them. The gravest and most serious works in Chinese literature abound in lies; their histories lie; and their scientific works lie. Nothing in China seems to have escaped this taint.

Essentially a people of fiction, the Chinese have given up as much time to the composition and perusal

of romances as any other nation on the globe; and this phase of lying is harmless enough in its way. Neither can it be said to interfere with the happiness of foreigners either in or out of China that Chinese medical, astrological, geomantic, and such works, pretend to a knowledge of mysteries we know to be all humbug. On the other hand, they ought to keep their lying to themselves and for their own special amusement. They have no right to circulate written and verbal reports that foreigners dig out babies' eyes and use them in their pharmacopeia. They have no right to publish such hideous, loathsome pamphlets, as the one which was some years ago translated into too faithful English by an American missionary, who had better have kept his talents to himself, or to post such inflammatory placards as the one which is placed at the end of this volume. Self-glorification, when no one suffers therefrom, is only laughable; and we shall take the liberty of presenting here the translation of an article which appeared in the *Shun Pao* of the 19th September 1874, as a specimen of the manner in which Chinamen delight to deceive even themselves on certain little points connected with the honour and glory of China. The writer says:—

"I saw yesterday in the *Peking Gazette* of the 10th September 1874 that the Prince of Kung had been degraded,—a fact received with mingled feelings of surprise and regret by natives of the Middle and Western kingdoms alike. For looking back to the last year of the reign Hsien Fêng, we find that not only internal trouble had not been set at rest when external difficulties began to spring up around us, and war and battle were the order of the day. To crown

all, His Majesty became a guest in the realms above, leaving only a child of tender years, unable to hold in his hands the reins of government. Then, with our ruler a youth and affairs generally in an unsettled state, sedition within and war without, although their Majesties the Empresses-Dowager directed the administration of government from behind the bamboo screen, the task of wielding the rod of empire must have been arduous indeed. Since that time, ten years and more, the Eighteen Provinces have been tranquillised; without, *western nations have yielded obedience and returned to a state of peace;* within, the empire has been fixed on a firm basis and has recovered its former vitality. Never, even in the glorious ages of the Chou or Hsia dynasties, has our national prosperity been so boundless as it is to-day. Whenever I have seen one among the people patting his stomach or carolling away in the exuberance of his joy, and have asked the cause of his satisfaction, he has replied, ' It is because of the loving-kindness of this our dynasty.' I ask what and whence is this loving-kindness of which he speaks? He answers me, 'It is the beneficent rule of their Majesties the Empresses-Dowager; it is the unspeakable felicity vouchsafed by Heaven to the Emperor; it is the loyalty and virtue of those in high places, of Tseng Kuo-fan, of Li Hung-chang, of Tso Tsung-t'ang.' These, however, are all provincial officials. Within the palace we have the Empresses-Dowager, and His Majesty the Emperor, toiling away from morn till dewy eve; but among the ministers of state who transact public business, receiving and making known the Imperial will, working early and late in the Cabinet, the Prince of Kung takes the foremost place; and it is through his agency, as natives and foreigners well know, that for many years China has been regaining her old status, so that any praise of their Imperial Majesties leads naturally on to eulogistic mention of our noble Premier. Hearing now that the Prince has incurred his master's displeasure, there are none who do not fear lest his previous services may be overlooked, hoping at the same time that the Emperor will be graciously pleased to take them into consideration and cancel his present punishment."

Lying, under any circumstances, is a very venial offence in China; it is, in fact, no offence at all, for

everybody is prepared for lies from all quarters, and takes them as a matter of course.

It is strange, however, that such a practical people should not have discovered long ago the mere expediency of telling the truth, in the same way that they have found mercantile honesty to be unquestionably the best policy, and that trade is next to impossible without it. But to argue, as many do, that China is wanting in morality, because she has adopted a dif· ferent standard of right and wrong from our own, is, *mutato nomine,* one of the most ridiculous traits in the character of the Chinese themselves. They regard us as culpable in the highest degree because our young men choose their own partners, marry, and set up establishments for-themselves, instead of bringing their wives to tend their aged parents, and live all together in harmony beneath the paternal roof. We are superior to the Chinese in our utter abhorrence of falsehood : in the practice of filial piety they beat us out of the field. " Spartan virtue " is a household word amongst us, but Sparta's claims to pre-eminence certainly do not rest upon her children's love either for honesty or for truth. The profoundest thinker of the nineteenth century has said that insufficient truthfulness " does more than any one thing that can be named to keep back civilisation, virtue, everything on which human happiness, on the largest scale, depends "—an abstract proposition which cannot be too carefully studied in connection with the present state of public morality in China, and the general welfare

of the people. Dr Legge, however, whose logical are apparently in an inverse ratio to his linguistic powers, rushes wildly into the concrete, and declares that every falsehood told in China may be traced to the example of Confucius himself. He acknowledges that "many sayings might be quoted from him, in which 'sincerity' is celebrated as highly and demanded as stringently as ever it has been by any Christian moralist," yet, on the ·strength of two passages in the Analects, and another in the "Family Sayings," he does not hesitate to say that "the example of him to whom they bow down as the best and wisest of men, encourages them to act, to dissemble, to sin." And what are these passages? In the first, Confucius applauds the modesty of an officer who, after boldly bringing up the rear on the occasion of a retreat, refused all praise for his gallant behaviour, attributing his position rather to the slowness of his horse. In the second, an unwelcome visitor calling on Confucius, the Master sent out to say he was sick, at the same time seizing his harpsichord and singing to it, "in order that Pei might hear him." Dr Legge lays no stress on the last half of this story—though it is impossible to believe that its meaning can have escaped his notice altogether. Lastly, when Confucius was once taken prisoner by the rebels, he was released on condition of not proceeding to Wei. "Thither, notwithstanding, he continued his route," and when asked by a disciple whether it was right to violate

his oath, he replied, "It was a forced oath. The spirits do not hear such."

We shall not attempt to defend Confucius on either of these indictments, taken separately and without reference to his life and teachings; neither do we wish to temper the accusation we ourselves have made against the Chinese, of being a nation of liars. But when it is gravely asserted that the great teacher who made truthfulness and sincerity his daily texts, is alone responsible for a vicious national habit which, for aught any one knows to the contrary, may be a growth of comparatively modern times, we call to mind the Horatian poetaster, who began his account of the Trojan war with the fable of Leda and the swan.

SUICIDE.

Suicide, condemned among western nations by human and divine laws alike, is regarded by the Chinese with very different eyes. Posthumous honours are even in some cases bestowed upon the victim, where death was met in a worthy cause. Such would be suicide from grief at the loss of a beloved parent, or from fear of being forced to break a vow of eternal celibacy or widowhood. Candidates are for the most part women, but the ordinary Chinaman occasionally indulges in suicide, urged by one or other of two potent causes. Either he cannot pay his debts and dreads the evil hour at the New Year, when coarse-tongued creditors will throng his door, or he may himself be anxious to settle a long-standing score of revenge against some one who has been unfortunate enough to do him an injury. For this purpose he commits suicide, it may be in the very house of his enemy, but at any rate in such a manner as will be sure to implicate him and bring him under the lash of the law. Nor is this difficult to effect in a country where the ends of justice are not satisfied unless a life is given for a life, where magistrates are venal, and the laws of evidence lax. Occasionally a young wife is driven to commit

I

suicide by the harshness of her mother-in-law, but this is of rare occurrence, as the consequences are terrible to the family of the guilty woman. The blood relatives of the deceased repair to the chamber of death, and in the injured victim's hand they place a broom. They then support the corpse round the room, making its dead arm move the broom from side to side, and thus sweep away wealth, happiness, and longevity from the accursed house for ever.

The following extract from the *Peking Gazette* of 14th September 1874, being a memorial by the Lieutenant Governor of Kiangsi, will serve to show—though in this case the act was not consummated—that under certain circumstances suicide is considered deserving of the highest praise. In any case, public opinion in China has very little to say against it :—

"The magistrate of the Hsin-yu district has reported to me that in the second year of the present reign (1863) a young lady, the daughter of a petty official, was betrothed to the son of an expectant commissioner of the Salt Gabelle, and a day was fixed upon for the marriage. The bridegroom, however, fell ill and died, on which his *fiancée* would have gone over to the family to see after his interment, and remain there for life as an unmarried wife. As it was, her mother would not allow her to do so, but beguiled her into waiting till her father, then away on business, should return home. Meanwhile, the old lady betrothed her to another man belonging to a different family, whereupon she took poison and nearly died. On being restored by medical aid, she refused food altogether ; and it was not until she was permitted to carry out her first intentions that she would take nourishment at all. Since then she has lived with her father and mother-in-law, tending them and her late husband's grandmother with the utmost care. They love her dearly, and are thus in a great measure consoled for the loss of their son.

Long thorns serve her for hair-pins : * her dress is of cotton cloth : her food consists of bitter herbs. Such privations she voluntarily accepts, and among her relatives there is not one but respects her.

" The truth of the above report having been ascertained, I would humbly recommend this virtuous lady, although the full time prescribed by law has not yet expired,† for some mark‡ of Your Majesty's approbation." Rescript :— Granted !

The only strange part in this memorial is that the girl's mother is not censured for trying to prevent her from acting the part* of a virtuous wife and filial daughter-in-law. It is also more than probable that her early attempts at suicide, rather than any subsequent household economy or dutiful behaviour, have secured for this lady the coveted mark of Imperial approbation.

Suicide, while in an unsound state of mind, is rare ; insanity itself, whether temporary or permanent, being extremely uncommon in China. Neither does the eye detect any of the vast asylums so numerous in England for the reception of lunatics, idiots, deaf-mutes, cripples, and the blind. There are a few such institutions here and there, but not enough to constitute a national feature as with us. They are only for the

* Instead of the elaborate gold and silver ornaments usually worn by Chinese women.

† A woman must be a widow before she is thirty years old, and remain so for thirty years before she is entitled to the above reward. This is both to guard against a possible relapse from her former virtuous resolution, and to have some grounds for believing that she was prompted so to act more by a sense of right than by any ungallant neglect on the part of the other sex.

‡ Generally a tablet or banner, inscribed with well-chosen words of praise.

poorest of the poor, and are generally of more benefit to
dishonest managers than to anybody else. And yet in
the streets of a Chinese town we see a far less number of
" unfortunates " than among our own highly civilised
communities. Blindness is the most common of the
above afflictions, so many losing their sight after an
attack of small-pox. But a Chinaman with a malfor-
mation of any kind is very seldom seen ; and, as we
have said before, lunacy appears to be almost unknown.
Such suicides as take place are usually well-premedi-
tated acts, and are committed either out of revenge,
or in obedience to the " despotism of custom."
Statistics are impossible, and we offer our conclusions,
founded upon observation alone, subject to whatever
correction more scientific investigators may hereafter
be enabled to produce.

TORTURE is commonly supposed to be practised by Chinese officials upon each and every occasion that a troublesome criminal is brought before them. The known necessity they are under of having a prisoner's confession before any " case " is considered complete, coupled with some few isolated instances of unusual barbarity which have come to the notice of foreigners, has probably tended to foster a belief that such scenes of brutality are daily enacted throughout the length and breadth of China as would harrow up the soul of any but a soulless native. The curious part of it all is that Chinamen themselves regard their laws as the quintessence of leniency, and themselves as the mildest and most gentle people of all that the sun shines upon in his daily journey across the earth —and back again under the sea. The truth lies of course somewhere between these two extremes. For just as people going up a mountain complain to those they meet coming down of the bitter cold, and are assured by the latter that the temperature is really excessively pleasant—so, from a western point of view certain Chinese customs savour of a cruelty long since forgotten in Europe, while the Chinese

enthusiast proudly compares the penal code of this
the Great Pure dynasty with the scattered laws and
unauthorised atrocities of distant and less civilised
ages.

The Han dynasty which lasted from about B.C. 200
to A.D. 200 has been marked by the historian as the
epoch of change. Before that time punishments of
all kinds appear to have been terribly severe, and the
vengeance of the law pursued even the nearest and
most distant relatives of a criminal devoted perhaps
to death for some crime in which they could possibly
have had no participation. It was then determined
that in future only rebellion should entail extirpation
upon the families of such seditious offenders, and at
the same time legal punishments were limited to five,
viz. : bambooing of two degrees of severity, banish-
ment to a certain distance for a certain time or for
life, and death. These were, however, frequently
exceeded by independent officers against whose acts
it would have been vain to appeal, and it was not
until the Sui dynasty (589—618 A.D.) that mutilation
of the body was absolutely forbidden. It may, indeed,
be said to have survived to the present day in the
form of the "lingering death" which is occasionally
prescribed for parricides and matricides, but that we
now know that this hideous fate exists only in words
and form. When it was first held to be inconsistent
with reason to mete out the same punishment to a
highway robber who kills a traveller for his purse, and
to the villain who takes away life from the author of

his being, a distinction was instituted accordingly, but we can only rest in astonishment that any executioner could be found to put such a horrible law into execution as was devised to meet the requirements of the case. First an arm was chopped off, then the other : the two legs in the same way. Two slits were made transversely on the breast, and the heart was torn out ; decapitation finished the proceedings. Now, a slight gash only is made across each collar-bone, and three gashes across the breast in the shape of the character meaning *one thousand*, and indicative of the number of strokes the criminal ought properly to have received. Decapitation then follows without delay. The absurd statement in the Shanghai *Daily News* of the 16th January last, that this punishment "is the most frightful inflicted, even in any of the darkest habitations of cruelty, at the present day," is utterly unworthy of that respectable journal, but only of a piece with the general ignorance that prevails among foreigners generally on topics connected with China and the Chinese. At the same time, it may fairly be pleaded that the error in question was due to disingenuousness on the part of the translator from the *Peking Gazette* who, mentioning that such a sentence had been lately passed upon two unhappy beings, adds that "they have been publicly sliced to death accordingly, with the usual formalities,"—which certainly might lead a mere outsider to conclude that the horrible decree had actually been put into execu-

tion. We may notice in passing that this so-called
" lingering death " is now almost invariably coupled
with the name of some poor lunatic who in a frenzy
of passion has killed either father or mother, some-
times both. Vide *Peking Gazette,* two or three times
every year. This is one of those pleasant fictions of
Chinese official life, which every one knows and every
one winks at. In nine cases out of ten, the unhappy
criminal is not mad at all ; but he is always entered
as such in the report of the committing magistrate,
who would otherwise himself be exposed to censure
and degradation for not having brought his district
to estimate at their right value the five* cardinal
relationships of mankind.

Under the present dynasty the use of torture is
comparatively rare, and mutilation of the person
quite unknown. Criminals are often thrust into
filthy dungeons of the most revolting description, and
are there further secured by a chain ; but except in
very flagrant cases, ankle-beating and finger-squeez-
ing, to say nothing of kneeling on chains and hanging
up by the ears, belong rather to the past than to the
present. The wife and children of a rebel chief may
pass their days in peace and quietness ; innocent
people are no longer made to suffer with the guilty.
A criminal under sentence of death for any crime
except rebellion may save his life and be released from

* Between, (1) sovereign and subject, (2) husband and wife, (3)
parent and child, (4) brothers, and (5) friends.

further punishment, if he can prove that an aged parent depends upon him for the necessaries of daily existence. The heavy bamboo, under the infliction of which sufferers not uncommonly died, has given place to the lighter instrument of punishment, which may be used severely enough for all practical purposes while it does not endanger life. The Emperor K'ang Hsi, whose name is inseparably connected with one of the most valuable lexicons that have ever been compiled, forbade bambooing across the upper part of the back and shoulders. "Near the surface," said this benign father of his people, "lie the liver and the lungs. For some trivial offence a man might be so punished that these organs would never recover from the effects of the blows." The ruling system of bribery has taken away from the bamboo its few remaining terrors for those whose means are sufficient to influence the hand which lays it on. Petty offences are chiefly expiated by a small payment of money to the gaoler, who lets the avenging bamboo fall proportionately light, or assists the culprit by every means in his power to shirk ·the degradation and annoyance of a week in the cangue.* These two are the only ordinary punishments we hear much about; torture, properly so called, is permitted under certain circumstances, but rarely if ever practised.

In further support of this most heterodox position, we beg to offer a translation of two chapters from

* A heavy wooden collar, taken off at night only if the sentence is a long one, or on payment of a bribe.

"Advice to Government Officials," a native work of much repute all over the Empire :—

"CHAPTER V.

"The infliction of the bamboo is open to abuse in various ways. For instance, the knots in the wood may not have been smoothed off; blows may be given inside the joints, instead of above the knees; the tip end instead of the flat of the bamboo may be used; each stroke may be accompanied by a drawing movement of the hand, or the same spot may be struck again after the skin has been broken, whereby the suffering of the criminal is very much increased. Similarly, the 'squeezing' punishment depends entirely for its severity on the length of the sticks employed, whether these are wet or dry, as well as upon the tightness of the string. Such points should be carefully looked to by the magistrate himself, and not left to his subordinates. At the time of infliction still greater precautions should be taken to prevent the possibility of any accident, and where the offence was committed under venial circumstances, some part of the punishment may be remitted if it is considered that enough has already been inflicted. Such punishments as pressing the knees to the ground, making prisoners kneel on chains, or burning their legs with hot irons, adopted under the specious pretence of not using the 'squeezing' torture, are among the most barbarous of prohibited practices, and are on no account to be allowed."

"CHAPTER VI.

"Lü Hsin-wu says, There are five classes of people who must be exempted from the punishment of the bamboo. (1.) The aged. (2.) The young. (3.) The sick. [It is laid down expressly by statute that the aged and the young must not be thus coerced into giving evidence, but there is a danger of overlooking this in a moment of anger.] (4.) The hungry and naked. [For thus to punish a beggar half dead with cold and hunger and destitute of friends to nurse him afterwards, would be equivalent to killing him outright.] (5.) Those who have already been beaten. [Whether in a brawl or by other officials. A second beating might result in death for which the presiding magistrate would be responsible.]

"There are five classes of people not to be hastily sentenced to the bamboo. (1.) Members of the Imperial family. [The relatives of his Majesty, even though holding no rank, are not, says the statute, to be hastily punished in this way. The case must be laid before the proper authorities.] (2.) Officials. [However low down in a scale, they are still part of the scheme of government; besides, it affects their good name ever afterwards.] (3.) Graduates. (4.) The official servants of your superiors. [Look out for the vase when you throw at the rat. Though you may be actually in the right, yet the dignity of your superiors might be compromised. A plain statement of the facts should be made out and privately handed to the official in question, leaving punishment in his hands. But to refrain from such a course through fear of the consequences would be weak indeed.] (5.) Women.

"There are also five cases in which temporary suspension of punishment is necessary. (1.) When the prisoner is under the influence of excitement, or (2.) anger. [The working classes are an obstinate lot and beating only increases their passion, so that they would die rather than yield. Arguments should first be used to show them their error, and then corporal punishment may be used without fear.] (3.) Or drink. [A drunken man doesn't know heaven from earth, how can he be expected to distinguish right from wrong? Besides he feels no pain, and further there is a risk of his insulting the magistrate. He ought to be confined until he is sober and then punished; but not in a cold place for fear of endangering his life.] (4.) Or when a man has just completed a journey, or (5.) when he is out of breath with running.

There are also five instances in which it is well for your own sake to put off punishment for a time. (1.) When you are in a rage. (2.) When you are drunk. (3.) When you are unwell. [For in the latter case the system is heated, and not only would you be more liable to improper infliction of punishment, but also to lose your temper; and thus injury would be done both to yourself and the prisoner.] (4.) When you can't see your way clearly as to the facts of the case. (5.) When you can't make up your mind as to the proper punishment. [For in difficult cases and when the prisoner in question is no ordinary man, it is just as well to look forward a little as to how the case is likely to end

before you apply the bamboo. It would never do to take such measures without some consideration, or you might suddenly find that you had by no means heard the last of it.]

" There are three classes of people who should not be beaten in addition to what they are to suffer. (1.) Those who are to have their fingers squeezed. (2.) Those who are to have the ankle frame applied. (3.) Those who are to be exposed in the cangue. [For if previously beaten they might be almost unable to move, or their sores might not heal, and death might perhaps ensue. The statute provides that they shall be beaten on release, but this might easily be forgotten in a moment of anger.

" There are three instances in which compassion should save the prisoners from the bamboo. (1.) When the weather is extremely cold or hot. (2.) When a festival is being celebrated. (3) When the prisoner has lately been bereaved. [A man who is mourning for his father, mother, wife, or child, should not be punished corporeally ; it might endanger his life.]

" There are three cases in which a beating deserved should nevertheless be remitted. (1.) When one of the litigants is considerably older than the other, he should not be beaten. (2.) When one of the litigants is an official servant, the other should not be beaten. [For although the former may be in the right, his opponent should be treated with leniency, for fear of people saying you protect your Yamen servants ; and lest in future, when the servant is in the wrong, no one will dare come forward to accuse him.] (3.) Workmen and others employed by the magistrate himself should not be bambooed by him, even if they deserve it.

" Three kinds of bambooing are forbidden. (1.) With the greater bamboo. [One stroke of the *greater* bamboo is counted as ten ; three with the *middle-sized*, and five with the *smaller*. Officials are often too free with, never too chary of, their punishments. With the smaller bamboo, used even to excess, life is not endangered. Besides, if the punishment is spread over a longer time, the magistrate has a longer interval in which to get calm. But with the heavy bamboo, there is no saying what injuries might be done even with a few blows.] (2.) It is forbidden to strike too low down. (3.) It is forbidden to allow petty officers to use unauthorised instruments of punishment. These five preceding clauses refer to cases in which

there is no doubt that punishment ought to be inflicted, but which officials are apt to punish too indiscriminately without due investigation of circumstances, whereby they infallibly stir up a feeling of discontent and insubordination. As regards those instances where punishment is deserved but should be temporarily suspended, a remission of part or the whole of the sentence may be granted as the magistrate sees fit. The great point is to admit an element of compassion, as thereby alone the due administration of punishment can be ensured."

" FÊNG-SHUI " has of late years grown to be such a common expression in the mouths of foreigners resident in China that it stands no poor chance of becoming gradually incorporated in the languages of more than one nation of the West. And yet, in spite of Dr Eitel's little hand-book, we may venture to assert that a very small percentage of those who are constantly using this phrase really have a distinct and correct idea as to the meaning of the words they employ. It is vaguely known that Fêng-shui is a powerful weapon in the hands of Chinese officials whereby they successfully oppose all innovations which savour of progress, and preserve unbroken that lethargic sleep in which China has been wrapt for so many centuries : beyond this all is mystery and doubt. Some say the natives themselves do not believe in it ; others declare they do ; others again think that the masses have faith, but that enlightened and educated Chinese scout the whole thing as a bare-faced imposture. Most Chinamen will acknowledge they are entirely ignorant themselves on the subject, though at the same time they will take great pains to impress on their hearers that certain friends, relatives, or acquaintances as the

case may be, have devoted much time and attention to this fascinating study and are downright professors of the art. They will further express their conviction of its infallibility, with certain limitations; and assert that there are occasions in life, when to call in the assistance of Fêng-shui is not only advisable but indispensable to human happiness.

For those who will not be at the trouble of reading for themselves Dr Eitel's valuable little book, we may explain that Fêng is the Chinese for *wind* and Shui for *water;* consequently Fêng-shui is wind-water; the first half of which, *wind*, cannot be comprehended, the latter half, *water*, cannot be grasped. It may be defined as a system of geomancy, by the *science* of which it is possible to determine the desirability of sites whether of tombs, houses, or cities, from the configuration of such natural objects as rivers, trees, and hills, and to foretell with certainty the fortunes of any family, community, or individual, according to the spot selected; by the *art* of which it is in the power of the geomancer to counteract evil influences by good ones, to transform straight and noxious outlines into undulating and propitious curves, rescue whole districts from the devastations of flood or pestilence, and "scatter plenty o'er a smiling land" which might otherwise have known the blight of poverty and the pangs of want. To perform such miracles it is merely necessary to build pagodas at certain spots and of the proper height, to pile up a heap of stones,

or round off the peak of some hill to which nature's rude hand has imparted a square and inharmonious aspect. The scenery round any spot required for building or burial purposes must be in accordance with certain principles evolved from the brains of the imaginative founders of the science. It is the business of the geomancer to discover such sites, to say if a given locality is or is not all that could be desired on this head, sometimes to correct errors which ignorant quacks have committed, or rectify inaccuracies which have escaped the notice even of the most celebrated among the fraternity. There may be too many trees, so that some must be cut down; or there may be too few, and it becomes necessary to plant more. Water-courses may not flow in proper curves; hills may be too high, too low, and of baleful shapes, or their relative positions one with another may be radically bad. Any one of these causes may be sufficient in the eyes of a disciple of Fêng-shui to account for the sudden outbreak of a plague, the gradual or rapid decay of a once flourishing town. The Fêng-shui of a house influences not only the pecuniary fortunes of its inmates, but determines their general happiness and longevity. There was a room in the British Legation at Peking in which two persons died with no great interval of time between each event; and subsequently one of the students lay there *in articulo mortis* for many days. The Chinese then pointed out that a tall chimney had been built opposite the door

leading into this room, thereby vitiating the Fêng-shui, and making the place uninhabitable by mortal man.

From the above most meagre sketch it is easy to understand that if the natural or artificial configuration of surrounding objects is really believed by the Chinese to influence the fortunes of a city, a family, or an individual, they are only reasonably averse to the introduction of such novelties as railways and telegraph poles, which must inevitably sweep away their darling superstition—never to rise again. And they *do* believe; there can be no doubt of it in the mind of any one who has taken the trouble to watch. The endless inconvenience a Chinaman will suffer without a murmur rather than lay the bones of a dear one in a spot unhallowed by the fiat of the geomancer; the sums he will subscribe to build a protecting pagoda or destroy some harmful combination; the pains he will be at to comply with well-known principles in the construction and arrangement of his private house— all prove that the iron of Fêng-shui has entered into his soul, and that the creed he has been suckled in is the very reverse of outworn. The childlike faith of his early years gradually ripens into a strong and vigorous belief against which ridicule is perhaps the worst weapon that can possibly be used. Nothing less than years of contact with foreign nations and deep draughts of that real science which is even now stealing imperceptibly upon them, will bring the Chinese

to see that Fêng-shui is a vain shadow, that it has played its allotted part in the history of a great nation, and is now only fit to be classed with such memories of by-gone glory as the supremacy of China, the bow and arrow, the matchlock, and the junk.

FEW things are more noticeable in China than the incessant chattering kept up by servants, coolies, and members of the working classes. It is rare to meet a string of porters carrying their heavy burdens along some country road, who are not jabbering away, one and all, as if in the very heat of some exciting discussion, and afraid that their journey will come to an end before their most telling arguments are exhausted. One wonders what ignorant, illiterate fellows like these can possibly have to talk about to each other in a country where beer-shop politics are unknown, where religious disputations leave no sting behind, and want of communication limits the area of news to half-a-dozen neighbouring streets in a single agricultural village. Comparing the uncommunicative deportment of a bevy of English bricklayers, who will build a house without exchanging much beyond an occasional pipe-light, with the vivacious gaiety of these light-hearted sons of Han, the problem becomes interesting enough to demand a solution of the question—What is it these Chinamen talk about ? And the answer is, *Money.* It may be said they talk, think, dream of nothing else. They certainly live for little besides

the hope of some day compassing, if not wealth, at any rate a competency. The temple of Plutus—to be found in every Chinese city—is rarely without a suppliant ; but there is no such hypocrisy in the matter as that of the Roman petitioner who would pray aloud for virtue and mutter " gold." And yet a rich man in China is rather an object of pity than otherwise. He is marked out by the officials as their lawful prey, and is daily in danger of being called upon to answer some false, some trumped-up accusation. A subscription list, nominally for a charitable purpose, for building a bridge, or repairing a road, is sent to him by a local magistrate, and woe be to him if he does not head it with a handsome sum. A ruffian may threaten to charge him with murder unless he will compromise instantly for Tls. 300 ; and the rich man generally prefers this course to proving his innocence at a cost of about Tls. 3000. He may be accused of some trivial disregard of prescribed ceremonies, giving a dinner-party, or arranging the preliminaries of his son's marriage, before the days of mourning for his own father have expired. No handle is too slight for the grasp of the greedy mandarin, especially if he has to do with anything like a recalcitrant millionaire. But this very mandarin himself, if compelled by age and infirmities to resign his place, is forced in his turn to yield up some of the ill-gotten wealth with which he had hoped to secure the fortunes of his family for many a generation to come. The young hawks peck out the old hawks' e'en without remorse.

The possession of money is therefore rather a source of anxiety than happiness, though this doesn't seem to diminish in the slightest degree the Chinaman's natural craving for as much of it as he can secure. At the same time, the abominable system of official extortion must go far to crush a spirit of enterprise which would otherwise most undoubtedly be rife. Everybody is so afraid of bringing himself within the clutch of the law, that innovation is quite out of the question.

Neither in the private life of a rich Chinese merchant do we detect the same keen enjoyment of his wealth as is felt by many an affluent western, to whom kindly nature has given the intellect to use it rightly. The former indulges in sumptuous feasts, but he does not collect around his table men who can only give him wit in return for his dinner; he rather seeks out men whose purses are as long as his own, from amongst whose daughters he may select a well-dowried mate for his dunderheaded son. He accumulates vast wardrobes of silk, satin, and furs; but he probably could not show a copy of the first edition of K'ang Hsi, or a single bowl bearing the priceless stamp of six hundred years ago. These articles are collected chiefly by scholars, who often go without a meal or two in order to obtain the coveted specimen; the rich merchant spends his money chiefly on dinners, dress, and theatrical entertainments, knowing and caring little or nothing about art. His conversation is also, like that of his humbler countrymen, confined

to one topic; if he is a banker, rates of exchange
haunt him day and night; whatever he is, he lives in
daily dread of the next phase of extortion to which
he will be obliged to open an unwilling purse. How
different from the literati of China who live day by
day almost from hand to mouth, eking out a scanty
subsistence by writing scrolls for door-posts, and per-
haps presenting themselves periodically at the public
examinations, only to find that their laboured essays
are thrown out amongst the ruck once more! Yet
these last are undeniably the happier of the two.
Having no wealth to excite the rapacious envy of
their rulers, they pass through life in rapt contempla-
tion of the sublime attributes of their Master, forget-
ting even the pangs of hunger in the elucidation of
some obscure passage in the Book of Changes, and
caring least of all for the idol of their unlettered
brethren, except in so far as it would enable them to
make more extensive purchases of their beloved books,
and provide a more ample supply of the "four jewels"*
of the scholar. Occasionally to be seen in the streets,
these literary devotees may be known by their respect-
able but poverty-stricken appearance, generally by
their spectacles, and always by their stoop, acquired
in many years of incessant toil. These are the men
who hate us with so deep a hate, for that we have
dared to set up a rival to the lofty position so long
occupied by Confucius alone. If we came in search
of trade only, they would tolerate, because they could

* Paper, pens (*i.e* brushes), ink, and the ink-slab.

understand our motives, and afford to despise ; but to bring our religion with us, to oppose the precepts of Christ to the immortal apophthegms of the Master, this is altogether too much for the traditions in which they have been brought up.

.

IT is a lamentable fact that although China has now been open for a considerable number of years both to trade and travellers, she is still a sealed book to the majority of intelligent Europeans as regards her manners and customs, and the mode of life of her people. Were it not so, such misleading statements as those lately published by a young gentleman in the service of H.I.M. the Emperor of China, and professing to give an account of a Chinese dinner, could never have been served up by half-a-dozen London newspapers as a piece of valuable information on the habits of Chinamen. There is so much that is really quaint, interesting, and worthy of record in the social etiquette observed by the natives of China, that no one with eyes to see and ears to hear need ever draw upon his imagination in the slightest degree. We do not imply that this has been done in the present instance. The writer has only erred through ignorance. He has doubtless been to a Chinese dinner where he "sat inside a glass door, and cigars were handed round after the repast," as many other brave men have been before him,—at Mr Yang's, the celebrated Peking pawnbroker. But had he been to more than that one, or

taken the trouble to learn something about the subject on which he was writing, he would have found out that glass doors and cigars are not natural and necessary adjuncts to a Chinese dinner. They are in fact only to be found at the houses of natives who have mixed with foreigners and are in the habit of inviting them to their houses. The topic is an interesting one, and deserves a somewhat elaborate treatment, both for its own sake as a study of native customs, and also to aid in dispelling a host of absurd ideas which have gathered round these everyday events of Chinese life. For it is an almost universal belief that Chinamen dine daily upon rats, puppy-dogs, and birds'-nest soup; whereas the truth is that, save among very poor people, the first is wholly unknown, and the two last are comparatively expensive dishes. Dog hams are rather favourite articles of food in the south of China, but the nests from which the celebrated soup is made are far too expensive to be generally consumed.

A dinner-party in China is a most methodical affair as regards precedence among guests, the number of courses, and their general order and arrangement. We shall endeavour to give a detailed and accurate account of such a banquet as might be offered to half-a-dozen friends by a native in easy circumstances. In the first place, no ladies would be present, but men only would occupy seats at the square, four-legged, "eight fairy" table. Before each there will be found a pair of chopsticks, a wine-cup, a small

saucer for soy, a two-pronged fork, a spoon, a tiny plate divided into two separate compartments for melon seeds and almonds, and a pile of small pieces of paper for cleaning these various articles as required. Arranged upon the table in four equidistant rows are sixteen small dishes or saucers which contain four kinds of fresh fruits, four kinds of dried fruits, four kinds of candied fruits, and four miscellaneous, such as preserved eggs, slices of ham, a sort of sardine, pickled cabbage, &c. These four are in the middle, the other twelve being arranged alternately round them. Wine is produced the first thing, and poured into small porcelain cups by the giver of the feast himself. It is polite to make a bow and place one hand at the side of the cup while this operation is being performed. The host then gives the signal to drink and the cups are emptied instantaneously, being often turned bottom upward as a proof there are no heel-taps. Many Chinamen, however, cannot stand even a small quantity of wine; and it is no uncommon thing when the feast is given at an eating-house, to hire one of the theatrical singing-boys to perform vicariously such heavy drinking as may be required by custom or exacted by forfeit. The sixteen small dishes above-mentioned remain on the table during the whole dinner and may be eaten of promiscuously between courses. Now we come to the dinner, which may consist of eight large and eight small courses, six large and six small, eight large and four small, or six large and four small, according to the

means or fancy of the host, each bowl of food constituting a course being placed in the middle of the table and dipped into by the guests with chopsticks or spoon as circumstances may require. The first is the commonest, and we append a bill of fare of an ordinary Chinese dinner on that scale, each course coming in its proper place.

I. Sharks' fins with crab sauce.
 1. Pigeons' eggs stewed with mushrooms.
 2. Sliced sea-slugs in chicken broth with ham.
II. Wild duck and Shantung cabbage.
 3. Fried fish.
 4. Lumps of pork fat fried in rice flour.
III. Stewed lily roots.
 5. Chicken mashed to pulp, with ham.
 6. Stewed bamboo shoots.
IV. Stewed shell-fish.
 7. Fried slices of pheasant.
 8. Mushroom broth.
Remove.—Two dishes of fried pudding, one sweet and the other salt, with two dishes of steamed puddings, also one sweet and one salt. [These four are put on the table together and with them is served a cup of almond gruel.]
V. Sweetened duck.
VI. Strips of boned chicken fried in oil.
VII. Boiled fish (of any kind) with soy.
VIII. Lumps of parboiled mutton fried in pork-fat.

These last four large courses are put on the table one by one and are not taken away. Subsequently a fifth, a bowl of soup, is added, and small basins of rice are served round, over which some of the soup is poured. The meal is then at an end. A *rince-bouche* is handed to each guest and a towel dipped in boiling water but well wrung out. With the last he mops his face all over, and the effect is much the

same as half a noggin of Exshaw diluted with a bottle of Schweppe. Pipes and tea are now handed round, though this is not the first appearance of tobacco on the scene. Many Chinamen take a whiff or two at their hubble-bubbles between almost every course, as they watch the performance of some broad farce which on grand occasions is always provided for their entertainment. Opium is served when dinner is over for such as are addicted to this luxury ; and after a few minutes, spent perhaps in arranging the prelimi-naries of some future banquet, the party, which has probably lasted from three to four hours, is no longer of the present but in the past.

A GREAT deal of trash has been committed to writing by various foreigners on the subject of female children in China. The prevailing belief in Europe seems to be that the birth of a daughter is looked upon as a mournful event in the annals of a Chinese family, and that a large percentage of the girls born are victims of a wide-spread system of infanticide, a sufficient number, however, being spared to prevent the speedy depopulation of the Empire. It became our duty only the other day to correct a mistake, on the part of a reverend gentleman who has been some twelve years a missionary in China, bearing on this very subject. He observed that "the Chinese are always profuse in their congratulations on the birth of a *son;* but if a girl is born, the most hearty word they can afford to utter is, ' girls too are necessary.' " Such a statement is very misleading, and cannot, in these days of enlightenment on Chinese topics, be allowed to pass unchallenged. " I hear you have obtained one thousand ounces of gold," is perhaps the commonest of those flowery metaphors which the Chinese delight to bandy on such an auspicious occasion ; another being, "You have a bright pearl in your hand," &c., &c.

The truth is that parents in China are just as fond of all their children as people in other and more civilised countries, where male children are also eagerly desired to preserve the family from extinction. The excess in value of the male over the female is perhaps more strongly marked among the Chinese, owing of course to the peculiarity of certain national customs, and not to any want of parental feeling; but, on the other hand, a very fair share both of care and affection is lavished upon the daughters either of rich or poor. They are not usually taught to read as the boys are, because they cannot enter any condition of public life, and education for mere education's sake would be considered as waste of time and money by all except very wealthy parents. Besides, when a daughter is married, not only is it necessary to provide her with a suitable dowry and trousseau, but she passes over to the house of her husband, there to adopt his family name in preference to her own, and contract new obligations to a father-and mother-in-law she may only have seen once or twice in her life, more binding in their stringency than those to the father and mother she has left behind. A son remains by his parents' side in most cases till death separates them for ever, and on him they rely for that due performance of burial rites which alone can ensure to their spirits an eternal rest. When old age or disease comes upon them, a son can go forth to earn their daily rice, and protect them from poverty, wrong, and insult, where a daughter would be only an additional

encumbrance. It is no wonder therefore that the birth of a son is hailed with greater manifestations of joy than is observable among western nations ; at the same time, we must maintain that the natural love of Chinese parents for their female offspring is not thereby lessened to any appreciable degree. No *red eggs* are sent by friends and relatives on the birth of a daughter as at the advent of the first boy, the hope and pride of the family ; but in other respects the customs and ceremonies practised on these occasions are very much the same. On the third day the milk-name is given to the child, and if a girl her ears are pierced for earrings. A little boiled rice is rubbed upon the lobe of the ear, which is then subjected to friction between the finger and thumb until it gets quite numb : it is next pierced with a needle and thread dipped in oil, the latter being left in the ear. No blood flows. Boys frequently have one ear pierced, as some people say, to make them look like little girls ; and up to the age of thirteen or fourteen, girls often wear their hair braided in a tail to make them look like little boys. But the end of the tail is always tied with *red* silk—the differentiating colour between youths and maids in China. And here we may mention that the colour of the silk which finishes off a Chinaman's tail differs according to circumstances. *Black* is the ordinary colour, often undistinguishable from the long tresses in which they take such pride ; *white* answers to deep crape with us, and proclaims that either the father or mother of the wearer has bid

adieu to this sublunary sphere ; * *green, yellow,* and *blue,* are worn for more distant relatives, or for parents after the first year of mourning has expired.

We will conclude with a curious custom which, as far as our inquiries have extended, seems to be universal. The first visitor, stranger, messenger, coolie, or friend, who comes to the house where a new-born baby lies, ignorant that such an event has taken place, is on no account allowed to go away without having first eaten a full meal. This is done to secure to the child a peaceful and refreshing night's rest ; and as Chinamen are always ready at a moment's notice to dispose of a feed at somebody else's expense, difficulties are not likely to arise on a score of a previous dinner.

* The verb "to die" is rarely used by the Chinese of their relatives. Some graceful periphrasis is adapted instead.

Books of travel are eagerly read by most classes of Chinese who have been educated up to the requisite standard, and long journeys have often been undertaken to distant parts of the Empire, not so much from a thirst for knowledge or love of a vagrant life, as from a desire to be enrolled among the numerous contributors to the deathless literature of the Middle Kingdom. Such travellers start with a full knowledge of the tastes of their public, and a firm conviction that unless they can provide sufficiently marvellous stories out of what they have seen and heard, the fame they covet is not likely to be accorded. No European reader who occupies himself with these works can fail to discover that in every single one of them invention is brought more or less into play; and that when fact is not forthcoming, the exigencies of the book are supplemented from the convenient resources of fiction. Of course this makes the accounts of Chinese travellers almost worthless, and often ridiculous; though strange to say, amongst the Chinese themselves, even to the grossest absurdities and most palpable falsehoods, there hardly attaches a

L

breath of that suspicion which has cast a halo round the name of Bruce.

We have lately come across a book of travels, in six thin quarto volumes, written by no less a personage than the father of Ch'ung-hou. It is a very handsome work, being well printed and on good paper, besides being provided with numerous woodcuts of the scenes and scenery described in the text. The author, whose name was Lin-ch'ing, was employed in various important posts; and while rising from the position of Prefect to that of Acting Governor-General of the two Kiang, travelled about a good deal, and was somewhat justified in committing his experiences to paper. We doubt, however, if his literary efforts are likely to secure him a fraction of the notoriety which the Tientsin Massacre has conferred upon his son. He never saw the moon shining upon the water, but away he went and wrote an ode to the celestial luminary, always introducing a few pathetic lines on the hardships of travel and the miseries of exile. One chapter is devoted to the description of a curious rock called the *Loom Rock*. It is situated in the Luhsi district of the Chang-chou prefecture in Hunan, and is perfectly inaccessible to man, as it well might be, to judge from the drawing of it by a native artist. From a little distance, however, caves are discernible hollowed out in the cliff, and in these the eye can detect various articles used in housekeeping, such as a teapot, &c.; and amongst others a *loom*. On a ledge of smooth rock a boat may be seen, as it were

hauled up out of the water. How these got there, and what is the secret of the place, nobody appears to know, but our author declares that he saw them with his own eyes. We have given the above particulars as to the whereabouts of the rock, in the hope that any European meditating a trip into Hunan may take the trouble to make some inquiries about this wonderful sight. The late Mr Margary must have passed close to it in his boat, probably without being aware of its existence—if indeed it does exist at all.

We cannot refrain from translating verbatim one passage which has reference to the English, and of which we fancy Ch'ung-hou himself would be rather ashamed since his visit to the Outside Nations. Here it is :—

"When the English barbarians first began to give trouble to the Inner Nation, they relied on the strength of their ships and the excellence of their guns. It was therefore proposed to build large ships and cast heavy cannon in order to oppose them. I represented, however, that vessels are not built in a day, and pointed out the difficulties in the way of naval warfare. I showed that the power of a cannon depends upon the strength of the powder, and the strength of the powder upon the sulphur and saltpetre; the latter determining the explosive force forwards and backwards, and the former, the same force towards either side. Therefore to ensure powder being powerful, there should be seven parts saltpetre out of ten. The English barbarians have got rattan ash which they can use instead of sulphur, but saltpetre is the product of China alone. Accordingly, I memorialised His Majesty to prohibit the export of saltpetre, and caused some thirty-seven thousand pounds to be seized by my subordinates."

THEORETICALLY, the Chinese are fatalists in the fullest sense of the word. Love of life and a desire to enjoy the precious boon as long as possible, prevent them from any such extended application of the principle as would be prejudicial to the welfare of the nation ; yet each man believes that his destiny is pre-ordained, and that the whole course of his life is mapped out for him with unerring exactitude. Happily, when the occasion presents itself, his thoughts are generally too much occupied with the crisis before him, to be able to indulge in any dangerous speculations on predestination and free-will ; his practice, therefore, is not invariably in harmony with his theory.

On the first page of a Chinese almanack for the current year, we have a curious woodcut representing a fly, a spider, a bird, a sportsman, a tiger, and a well. Underneath this strange medley is a legend couched in the following terms :—" Predestination in all things ! " The letterpress accompanying the picture explains that the spider had just secured a fat fly, and was on the point of making a meal of him, when he was espied by a hungry bird which swooped down on both. As the bird was making off to its nest with

this delicious mouthful, a sportsman who happened to be casting round for a supper, brought it down with his gun, and was stooping to pick it up, when a tiger, also with an empty stomach, sprang from behind upon the man, and would there and then have put an end to the drama, but for an ugly well, on the brink of which the bird had dropped, and into which the tiger, carried on by the impetus of his spring, tumbled head-long, taking with him man, bird, spider, and fly in one fell career to the bottom. This fable embodies popular ideas in China with regard to predestination, by virtue of which calamity from time to time over-takes doomed victims, as a punishment for sins com-mitted in their present or a past state of existence. Coupled with this belief are many curious sayings and customs, the latter of which often express in stronger terms than language the feelings of the people. For instance, at the largest centre of population in the Eighteen Provinces, there is a regulation with regard to the porterage by coolies of wine and oil, which ad-mirably exemplifies the subject under consideration. If on a wet and stormy day, or when the ground is covered with snow, a coolie laden with either of the above articles slips and falls, he is held responsible for any damage that may be done; whereas, if he tumbles down on a fine day when the streets are dry, and there is no apparent cause for such an accident, the owner of the goods bears whatever loss may occur. The idea is that on a wet and slippery day mere exercise of human caution would be sufficient to avert the dis-

aster, but happening in bright, dry weather, it becomes indubitably a manifestation of the will of Heaven. In the same way, an endless run of bad luck or some fearful and overwhelming calamity, against which no mortal foresight could guard, is likened to the burning of an *ice-house*, which, from its very nature, would almost require the interposition of Divine power to set it in a blaze. In such a case, he who could doubt the reality of predestination would be ranked, in Chinese eyes, as little better than a fool. And yet when these emergencies arise we do not find the Chinese standing still with their hands in their sleeves (for want of pockets), but working away to stop whatever mischief is going on, as if after all the will of Heaven may be made amenable to human energy. It is only when an inveterate gambler or votary of the opium-pipe has seen his last chance of solace in this life cut away from under him, and feels himself utterly unable any longer to stem the current, that he weakly yields to the force of his destiny, and borrows a stout rope from a neighbour, or wanders out at night to the brink of some deep pool never to return again.

There is a charming episode in the second chapter of the "Dream of the Red Chamber," where the father of Pao-yü is anxious to read the probable destiny of his infant son. He spreads before the little boy, then just one year old, all kinds of different things, and declares that from whichever of these the baby first seizes, he will draw an omen as to his future career in life. We can imagine how he longed for his boy to

grasp the manly *bow*, in the use of which he might some day rival the immortal archer Pu :—the *sword*, and live to be enrolled a fifth among the four great generals of China :—the *pen*, and under the favouring auspices of the god of literature, rise to assist the Son of Heaven with his counsels, or write a commentary upon the Book of Rites. Alas for human hopes! The naughty baby, regardless alike of his father's wishes and the filial 'code, passed over all these glittering instruments of wealth and power, and devoted his attention exclusively to some hair-pins, pearl-powder, rouge, and a lot of women's head-ornaments.

WERE any wealthy philanthropist to consult us as to the disposal of his millions with a view to ensure the greatest possible advantages to the greatest possible number, we should unhesitatingly recommend him to undertake the publication of a Chinese newspaper, to be sold at a merely nominal figure per copy. Under skilled foreign guidance, and with the total exclusion of religious topics, more would be effected in a few years for the real happiness of China and its ultimate conversion to western civilisation, than the most hopeful enthusiast could venture to predict. The *Shun-pao*, edited in Shanghai by Mr Ernest Major, is doing an incredible amount of good in so far as its influence extends; but the daily issue of this widely-circulated paper amounts only to about four thousand copies, or one to every hundred thousand natives! Missionary publications are absolutely useless, as they have a very limited sale beyond the circle of converts to the faith; but a *colporteur* of religious books informed us the other day that he was continually being asked for the *Shun-pao*. Now the *Shun-pao* owes its success so far to the fact that it is a pure

money speculation, and therefore an undertaking intelligible enough to all Chinamen. Not only are its columns closed to anything like proselytising articles, but they are open from time to time to such tit-bits of the miraculous as are calculated to tickle the native palate, and swell the number of its subscribers. Therefore, to avert suspicion, it would be necessary to make a charge, however small, while at the same time such bogy paragraphs as occasionally appear in the columns of the *Shun-pao* might be altogether omitted.

Our attention was called to this matter by a charming description in the *Shun-pao* of a late balloon ascent from Calais, which was so nearly attended with fatal results. Written in a singularly easy style, and going quite enough into detail on the subject of balloons generally to give an instructive flavour to its remarks, this article struck us as being the identical kind of " light science for leisure hours " so much needed by the Chinese; and it compared most favourably with a somewhat heavy disquisition on aëronautic topics which appeared some time back in the *Peking Magazine,* albeit the latter was accompanied by an elaborate woodcut of a balloon under way. There is so much that is wonderful in the healthy regions of fact which might with mutual advantage be imparted to a reading people like the Chinese, that it is quite unnecessary to descend to the gross, and too often indecent, absurdities of fiction. Much indeed that is not actually marvellous might be put into language which would rivet the attention of Chinese readers.

The most elementary knowledge, according to our standard, is almost always new, even to the profoundest scholar in native literature : the ignorance of the educated classes is something appalling. On the other hand, all who have read their *Shun-pao* with regularity, even for a few months, are comparatively enlightened. We heard the other day of a Tao-t'ai who was always meeting the phrase " International Law " in the above paper, and his curiosity at length prompted him to make inquiries, and finally to purchase a copy of Dr Martin's translation of " Wheaton." He subsequently complained bitterly that much of it was utterly unintelligible; and judging from our own limited experience of the translation, we think His Excellency's objection not altogether groundless.

Of the domestic life of foreigners, the Chinese, with the exception of a few servants, know absolutely nothing ; and equally little of foreign manners, customs, or etiquette. We were acquainted with one healthy Briton who was popularly supposed by the natives with whom he was thrown in contact to eat a whole leg of mutton every day for dinner ; and a high native functionary, complaining one day of some tipsy sailors who had been rioting on shore, observed that " he knew foreigners always got drunk on Sundays, and had the offence been committed on that day he would have taken no notice of it; but," &c., &c. They have vague notions that filial piety is not considered a virtue in the West, and look upon our system of contracting marriages as objectionable in the extreme.

They think foreigners carry whips and sticks only for purposes of assault, and we met a man the other day who had been wearing a watch for years, but was in the habit of never winding it up till it had run down. This we afterwards found out to be quite a common custom among the Chinese, it being generally believed that a watch cannot be wound up whilst going ; consequently, many Chinamen keep two always in use, and it is worth noticing that watches in China are almost invariably sold in pairs. The term " foreign devil " is less frequently heard than formerly, and sometimes only for the want of a better phrase. Mr Alabaster, in one of his journeys in the interior, was politely addressed by the villagers as *His Excellency the Devil.* The Chinese settlers in Formosa call themselves "foreign men," but they call us " foreign things;" for, they argue, if we called you foreign men, what should we call ourselves? The *Shun-pao* deserves much credit for its unvarying use of *western* instead of *outside* nations when speaking of foreign powers, but the belief is still very prevalent that we all come from a number of small islands scattered round the coast of one great centre, the Middle Kingdom.

And so we might go on multiplying *ad nauseam* instances of Chinese ignorance in trivial matters which an ably-conducted journal has it in its power to dispel. We are so dissimilar from the Chinese in our ways of life, and so unlike them in dress and facial appearance, that it is only many years of commercial intercourse on the present familiar footing which will

cause them to regard us as anything but the barbarians they call us.　　Red hair and blue eyes may make up what Baron Hübner would euphemistically describe as the " beau type d'un gentleman anglais," but when worn with a funny-shaped hat, a short coat, tight trousers, and a Penang lawyer, the picture produced on the retina of a Chinese mind is unmistakably that of a " foreign devil."

OF all their cherished ceremonies, there are none the Chinese observe with more scrupulous exactness than those connected with death and mourning. We have just heard of the Governor of Kiangsu going into retirement because of the decease of his mother; and so he will remain, ineligible to any office, for the space of three years. He will not shave his head for one hundred days. For forty-nine nights he will sleep in a hempen garment, with his head resting on a brick and stretched on the hard ground, by the side of the coffin which holds the remains of the parent who gave him birth. He will go down upon his knees and humbly kotow to each friend and relative at their first meeting after the sad event—a tacit acknowledgment that it was but his own want of filial piety which brought his beloved mother prematurely to the grave. To the coolies who bear the coffin to its resting-place on the slope of some wooded hill, or beneath the shade of a clump of dark-leaved cypress trees, he will make the same obeisance. Their lives and properties are at his disposal day and night; but he has now a favour to ask which no violence could secure, and pleads thus that his mother's body may be

carried gently, without jar or concussion of any kind.
He will have her laid by the side of his father, in a
coffin which cost perhaps £100, and repair thither
periodically to appease her departed spirit with votive
offerings of fruit, vegetables, and pork.

Immediately after the decease of a parent, the
children and other near relatives communicate the
news to friends living farther off, by what is called an
" announcement of death," which merely states that
the father or mother, as the case may be, has died,
and that they, the survivors, are entirely to blame.
With this is sent a " sad report," or in other words a
detailed account of deceased's last illness, how it
originated, what medicine was prescribed and taken,
and sundry other interesting particulars. Their
friends reply by sending a present of money to help
defray funeral expenses, a present of food or joss-
stick, or even a detachment of priests to read the
prescribed liturgies over the dead. Sometimes a large
scroll is written and forwarded, inscribed with a few
such appropriate words as—" A hero has gone !"
When all these have been received, the members of
the bereaved family issue a printed form of thanks,
one copy being left at the house of each contributor
and worded thus :—" This is to express the thanks of
. . . . the orphaned son who weeps tears of blood
and bows his head : of the mourning brother
who weeps and bows his head : of the mourn-
ing nephew who wipes away his tears and bows his
head."

It is well known that all old and even middle-aged people in China like having their coffins prepared ready for use. A dutiful son will see that his parents are thus provided, sometimes many years before their death, and the old people will invite relatives or friends to examine and admire both the materials and workmanship, as if it were some beautiful picture or statue of which they had just cause to be proud. Upon the coffin is carved an inscription with the name and titles of its occupant; if a woman, the name of her husband. At the foot of the coffin are buried two stone tablets face to face; one bears the name and titles of the deceased, and the other a short account of his life, what year he was born in, what were his achievements as a scholar, and how many children were born to him. Periods of mourning are regulated by the degrees of relationship to the dead. A son wears his white clothes for three years—actually for twenty-eight months; and a wife mourns her husband for the same period. The death of a wife, however, calls for only a single year of grief; for, as the Sacred Edict points out, if your wife dies you can marry another. The same time suffices for brother, sister, or child. Marriages contracted during these days of mourning are not only invalid, but the offending parties are punished with a greater or less number of blows according to the gravity of the offence. Innumerable other petty restrictions are imposed by national or local custom, which are observed with a certain amount of fidelity, though instances are not wanting

where the whole thing is shirked as inconvenient and a bore.

Cremation, once the prevailing fashion in China, is now reserved for the priest of Buddha alone,—that self-made outcast from society, whose parting soul relies on no fond breast, who has no kith or kin to shed "those pious drops the closing eye requires;" but who, seated in an iron chair beneath the miniature pagoda erected in most large temples for that purpose, passes away in fire and smoke from this vale of tears and sin to be absorbed in the blissful nothingness of an eternal Nirvâna.

INQUESTS in China serve, unfortunately, but to illustrate one more phase of the folly and ignorance which hopelessly overshadow the vast area of its Empire. For although the Chinese justly regard such investigations as matters of paramount importance, and the office of coroner devolves upon a high functionary—the district magistrate—yet the backward state of science on the one hand, and the necessity the ruling classes have been under of supplying this deficiency on the other, have combined to produce at once the most deplorable and the most laughable results. Two good-sized volumes of "Instructions to Coroners," beautifully printed on white paper and altogether handsomely got up, are published under the authority of the Government, and copies of this book are to be found in the offices of every magistrate throughout the Empire. It is carefully studied even by the underlings who play only subordinate parts on such occasions, and the coroner himself generally carries his private copy with him in his sedan-chair to the very scene of the inquest. From this work the following sketch has been compiled, for though it has been our fate to be present at more than one of the

M

lamentable exhibitions thus dignified by the name of inquest, and to have had ocular demonstration of the absurdities there perpetrated, it will be more satisfactory to stick closely to the text of an officially-recognised book, the translation of which helped to while away many a leisure hour.

The first chapter opens as follows :—

"There is nothing more sacred than human life: there is no punishment greater than death. A murderer gives life for life: the law shows no mercy. But to obviate any regrets which might be occasioned by a wrong infliction of such punishment, the validity of any confession and the sentence passed are made to depend on a satisfactory examination of the wounds. If these are of a *bonâ fide* nature [*i.e.*, not counterfeit], and the confession of the accused tallies therewith, then life may be given for life, that those who know the laws may fear them, that crime may become less frequent among the people, and due weight be attached to the sanctity of human existence. If an inquest is not properly conducted, the wrong of the murdered man is not redressed, and new wrongs are raised up amongst the living; other lives may be sacrificed, and both sides roused to vengeance of which no man can foresee the end."

On this it is only necessary to remark that the "validity" of a confession is an important point in China, since substitutes are easily procurable at as low a rate as from £20 to £50 a life.

The duties of a Chinese coroner are by no means limited to *post mortem* investigations ; he visits and examines any one who has been dangerously wounded, and fixes a date within which the accused is held responsible for the life of his victim.

"Murders are rarely the result of premeditation, but can be traced, in the majority of cases, to a brawl. The statute which

treats of wounding in a brawl attaches great weight to the 'death-limit,' which means that the wounded man be handed over to the accused to be taken care of and provided with medical aid, and that a limit of time be fixed, on the expiration of which punishment be awarded according to circumstances. Now the relatives of a wounded man, unless their ties be of the closest, generally desire his death that they may extort money from his slayer; but the accused wishes him to live that he himself may escape death, and therefore he leaves no means untried to restore his victim to health. This institution of the 'death-limit' is a merciful endeavour to save the lives of both."

One whole chapter is devoted to a division of the body into vital and non-vital parts. Of the former there are twenty-two altogether, sixteen before and six behind; of the latter fifty-six, thirty-six before and twenty behind. Every coroner provides himself with a form, drawn up according to these divisions, and on this he enters the various wounds he finds on the body at the inquest.

"Do not," say the Instructions, "deterred by the smell of the corpse, sit at a distance, your view intercepted by the smoke of fumigation, letting the assistants call out the wounds and enter them on the form, perhaps to garble what is of importance and to give prominence to what is not."

The instructions for the examination of the body from the head downwards are very explicit, and among them is one sentence by virtue of which a Chinese judge would have disposed of the Tichborne case without either hesitation or delay.

"Examine the cheeks to see whether they have been tattooed or not, or whether the marks have been obliterated. In the latter case, cut a slip of bamboo and tap the parts; the tattooing will then re-appear."

In cases where the wounds are not distinctly
visible, the following directions are given :—

"Spread a poultice of grains, and sprinkle some vinegar upon the
corpse in the open air. Take a piece of new oiled silk, or a transpa-
rent oil-cloth umbrella, and hold it between the sun and the parts
you want to examine. The wounds will then appear. If the day is
dark or rainy, use live charcoal [instead of the sun]. Suppose there
is no result, then spread over the parts pounded white prunes with
more grains and vinegar, and examine closely. If the result is still
imperfect, then take the flesh only of the prune, adding cayenne
pepper, onions, salt, and grains, and mix it up into a cake. Make
this very hot, and having first interposed a sheet of paper, lay it on
the parts. The wound will then appear."

Hot vinegar and grains are always used previous to
an examination of the body to soften it and cause the
wounds to appear more distinctly.

"But in winter, when the corpse is frozen hard, and no amount
of grains and vinegar, however hot, or clothes piled up, however
thick, will relax its rigidity, dig a hole in the ground of the length
and breadth of the body and three feet in depth. Lay in it a
quantity of fuel and make a roaring fire. Then dash over it vinegar,
which will create dense volumes of steam, in the middle of which
place the body with all its dressings right in the hole ; cover it over
with clothes and pour on more hot vinegar all over it. At a distance
of two or three feet from the hole on either side of it light fires,
and when you think the heat has thoroughly penetrated, take away
the fire and remove the body for examination."

It is always a great point with the coroner to secure
as soon as possible the fatal weapon. If a long time
has elapsed between the murder and the inquest, and
no traces of blood are visible on the knife or sword
which may have been used, "heat it red hot in a
charcoal fire, and pour over it a quantity of first-rate
vinegar. The stains of blood will at once appear."

The note following this last sentence is still more extraordinary :—

"An inquest was held on the body of a man who had been murdered on the high road, and at first it was thought that the murder had been committed by robbers, but on examination the corpse was found to be fully clothed and bearing the marks of some ten or more wounds from a sickle. The coroner pointed out that robbers kill their victims for the sake of booty, which evidently was not the case in the present instance, and declared revenge to be at the bottom of it all. He then sent for the wife of the murdered man, and asked her if her husband had lately quarrelled with any-body. She replied No, but stated that there had been some high words between her husband and another man to whom he had refused to lend money. The coroner at once despatched his runners to the place where this man lived, to bid the people of that village produce all their sickles without delay, at the same time informing them that the concealment of a sickle would be tantamount to a con-fession of guilt. The sickles were accordingly produced, in number about eighty, and spread out upon the ground. The season being summer there were a great quantity of flies, all of which were attracted by one particular sickle. The coroner asked to whom this sickle belonged, and lo ! it belonged to him with whom the murdered man had quarrelled about a loan. On being arrested, he denied his guilt ; but the coroner pointed to the flies settling upon the sickle, attracted by the smell of blood, and the murderer bent his head in silent acknowledgment of his crime."

Inquests are often held in China many years after the death of the victim. Give a Chinese coroner merely the dry and imperfect skeleton of a man known to have been murdered, and he will generally succeed in fixing the guilt on some one. To supple-ment this by full and open confession of the accused is a matter of secondary difficulty in a country where torture may at any moment be brought to

bear with terrible efficacy in the cause of justice and truth. Its application, however, is extremely rare.

"Man has three hundred and sixty-five bones, corresponding to the number of days it takes the heavens to revolve. The skull of a man, from the nape of the neck to the top of the head, consists of eight pieces—that of a Ts'ai-chow man, of nine ; women's skulls are of six pieces. Men have twelve ribs on either side ; women have fourteen."

The above being sufficient to show where the Chinese are with regard to the structure of the human frame, we will now proceed to the directions for examining bones, it may be months or even years after death.

"For the examination of bones the day should be clear and bright. First take clean water and wash them, and then with string tie them together in proper order so that a perfect skeleton is formed, and lay this on a mat. Then make a hole in the ground, five feet long, three feet broad and two feet deep. Throw into this plenty of firewood and charcoal, and keep it burning till the ground is thoroughly hot. Clear out the fire and pour in two pints of good spirit and five pounds of strong vinegar. Lay the bones quickly in the steaming pit and cover well up with rushes, &c. Let them remain there for two or three hours until the ground is cold, when the coverings may be removed, the bones taken to a convenient spot, and examined under a red oil-cloth umbrella.

"If the day is dark or rainy the 'boiling' method must be adopted. Take a large jar and heat in it a quantity of vinegar; then having put in plenty of salt and white prunes, boil it altogether with the bones, superintending the process yourself. When it is boiling fast, take out the bones, wash them in water, and hold up to the light. The wounds will be perfectly visible, the blood having soaked into the wounded parts, marking them with red or dark blue or black.

"The above method is, however, not the only one. Take a new yellow oil-cloth umbrella from Hangchow, hold it over the bones, and every particle of wound hidden in the bones will be clearly visible. In cases where the bones are old and the wounds have

been obliterated by long exposure to wind and rain or dulled by frequent boilings, it only remains to examine them in the sun under a yellow umbrella, which will show the wounds as far as possible.

"There must be no zinc boiled with the bones or they will become dull.

"Bones which have passed several times through the process of examination become quite white and exactly like uninjured bones; in which case, take such as should show wounds and fill them with oil. Wait till the oil is oozing out all over, then wipe it off and hold the bone up to the light; where there are wounds the oil will collect and not pass; the clear parts have not been injured.

"Another method is to rub some good ink thick and spread it on the bone. Let it dry, and then wash it off. Where there are wounds, and there only, it will sink into the bone. Or take some new cotton wool and pass it over the bone. Wherever there is a wound some will be pulled out [by the jagged parts of the bone]."

A whole chapter is devoted to counterfeit wounds, the means of distinguishing them from real wounds, and the manner in which they are produced. Section 2 of the thirteenth chapter is on a cognate subject, namely, to ascertain whether wounds were inflicted before or after death :—

"If there are several dark-coloured marks on the body, take some water and let it fall drop by drop on to them. If they are wounds the water will remain without trickling away; if they are not wounds, the water will run off. In examining wounds, the finger must be used to press down any livid or red spot. If it is a wound it will be hard, and on raising the finger will be found of the same colour as before.

"Wounds inflicted on the bone leave a red mark and a slight appearance of saturation, and where the bone is broken there will be at either end a halo-like trace of blood. Take a bone on which there are marks of a wound and hold it up to the light; if these are of a fresh-looking red, the wound was inflicted before death and penetrated to the bone; but if there is no trace of saturation from blood, although there is a wound, it was inflicted after death."

In a chapter on wounds from kicks, the following curious instructions are given regarding a "bone-method" of examination :—

"To depend on the evidence of the bone immediately below the wound would be to let many criminals slip through the meshes of the law. Where wounds have been thus inflicted, no matter on man or woman, the wounds will be visible on the upper half of the body and not on the lower. For instance, they will appear in a male at the roots of either the top or bottom teeth, inside ; on the right hand if the wound was on the left, and *vice versâ;* in the middle if the wound was central. In women, the wounds will appear on the gums right or left as above."

The next extract needs no comment, except perhaps that it forms the most cherished of all beliefs in the whole range of Chinese medical jurisprudence :—

"The bones of parents may be identified by their children in the following manner. Let the experimenter cut himself or herself with a knife and cause the blood to drip on to the bones ; then, if the relationship is an actual fact the blood will sink into the bone, otherwise it will not. *N.B.* Should the bones have been washed with salt water, even though the relationship exists, yet the blood will not soak in. This is a trick to be guarded against beforehand.

"It is also said that if parent and child, or husband and wife, each cut themselves and let the blood drip into a basin of water the two bloods will mix, whereas that of two people not thus related will not mix.

"Where two brothers who may have been separated since childhood are desirous of establishing their identity as such, but are unable to do so by ordinary means, bid each one cut himself and let the blood drip into a basin. If they are really brothers, the two bloods will congeal into one ; otherwise not. But because fresh blood will always congeal with the aid of a little salt or vinegar, people often smear the basin over with these to attain their own ends and deceive others ; therefore, always wash out the basin you are

going to use or buy a new one from a shop. Thus the trick will be defeated.

" The above method of dropping blood on the bones may be used even by a grandchild, desirous of identifying the remains of his grandfather; but husband and wife, not being of the same flesh and blood, it is absurd to suppose that the blood of one would soak into the bones of the other. For such a principle would apply with still more force to the case of a child, who had been suckled by a foster-mother and had grown up, indebted to her for half its existence. With regard to the water method, if the basin used is large and full of water, the bloods will be unable to mix from being so much diluted ; and in the latter case where there is no water, if the interval between dropping the two bloods into the basin is too long, the first will get cold and they will not mix."

Not content with holding an inquest on the bones of a man who may have been murdered five years before, a Chinese coroner quite as often proceeds gravely to examine the wounds of a corpse which has been reduced to ashes by fire and scattered to the four winds of heaven. No mere eyewitness would dare to relate the singular process by which such a result is achieved ; but directions exist in black and white, of which the following is a close translation :—

" There are some atrocious villains who, when they have murdered any one, burn the body and throw the ashes away, so that there are no bones to examine. In such cases you must carefully find out at what time the murder was committed and where the body was burnt. Then, when you know the place, all witnesses agreeing on this point, you may proceed without further delay to examine the wounds. The mode of procedure is this. Put up your shed near where· the body was burnt, and make the accused and witnesses point out themselves the very spot. Then cut down the grass and weeds growing on

this spot, and burn large quantities of fuel till the place is extremely hot, throwing on several pecks of hempseed. By and by brush the place clean, and then, if the body was actually burnt on this spot, the oil from the seed will be found to have sunk into the ground in the form of a human figure, and wherever there were wounds on the dead man, there on this figure the oil will be found to have collected together, large or small, square, round, long, short, oblique, or straight, exactly as they were inflicted. The parts where there were no wounds will be free from any such appearances. But supposing you obtain the outline only without the necessary detail of the wounds, then scrape away the masses of oil, light a brisk fire on the form of the body and throw on grains mixed with water. Make the fire burn as fiercely as possible, and sprinkle vinegar, instantly covering it over with a new well-varnished table. Leave the table on a little while and then take it off for examination. The form of the body will be transferred to the table and the wounds will be distinct and clear in every particular.

"If the place is wild and some time has elapsed since the deed was done, so that the very murderer does not remember the exact spot, inquire carefully in what direction it was with regard to such and such a village or temple and about how far off. If all agree on this point, proceed in person to the place, and bid your assistants go round about searching for any spots where the grass is taller and stronger than usual, marking such with a mark. For where a body has been burnt the grass will be darker in hue, more luxuriant, and taller than that surrounding it, and will not lose these characteristics for a long time, the fat and grease of the body sinking down to the roots of the grass and causing the above results. If the spot is on a hill, or in a wild place where the vegetation is very luxuriant, then you must look for a growth about the height of a man. If the burning took place on stony ground, the crumbly appearance of the stones must be your guide; this simplifies matters immensely."

Such, then, are a few of the absurdities which pass muster among the credulous people of China as the result of deep scientific research; but whether the educated classes—more especially those individuals

who devote themselves in the course of their official
duties to the theory and practice of *post mortem*
examinations—can be equally gulled with the gaping
crowd around them, we may safely leave our readers
to decide for themselves.

SECTION IV. of the valuable work which formed the
basis of our preceding sketch, is devoted to the enu-
meration of methods for restoring human life after
such casualties as drowning, hanging, poisoning, &c.,
some hours and even days after vitality has to all
appearances ceased. We shall quote as before from
our own literal translation.

"Where a man has been hanging from morning to night, even
though already cold, a recovery may still be effected. Stop up the
patient's mouth tightly with your hand, and in a little over four
hours respiration will be restored. *Or*, Take equal parts of finely-
powdered soap-bean and anemone hepatica, and blow a quantity
of this—about as much as a bean—into the patient's nostrils.

"In all cases where men or women have been hanged, a recovery
may be effected even if the body has become stiff. You must not
cut the body down, but, supporting it, untie the rope and lay it
down in some smooth place on its back with the head propped up.
Bend the arms and legs gently, and let some one sitting behind pull
the patient's hair tightly. Straighten the arms, let there be a free
passage through the wind-pipe, and let two persons blow incessantly
into the ears through a bamboo tube or reed, rubbing the chest all
the time with the hand. Take the blood from a live fowl's comb,
and drop it into the throat and nostrils—the left nostril of a woman,
the right of a man ; also using a cock's comb for a man, a hen's for a
woman. Re-animation will be immediately effected. If respiration
has been suspended for a long time, there must be plenty of blowing

and rubbing; do not think that because the body is cold all is neces-
sarily over.

" Where a man has been in the water a whole night, a recovery
may still be effected. Break up part of a mud wall and pound it to
dust; lay the patient thereon on his back, and cover him up with
the same, excepting only his mouth and eyes. Thus the water will
be absorbed by the mud, and life will be restored. This method
is a very sure one, even though the body has become stiff.

" In cases of injury from scalding, get a large oyster and put it in a
basin with its mouth upwards somewhere quite away from anybody.
Wait till its shell opens, and then shake in from a spoon a little
Borneo camphor, mixed and rubbed into a powder with an equal por-
tion of genuine musk. The oyster will then close its shell and its
flesh will be melted into a liquid. Add a little more of the above
ingredients, and with a fowl's feather brush it over the parts and
round the wound, getting nearer and nearer every time till at last
you brush it into the wound; the pain will thus gradually cease.
A small oyster will do if a large one is not to be had. This is a
first-rate prescription.

" Where a man has fallen into the water in winter, and has quite
lost all consciousness from cold, if there is the least warmth about
the chest, life may still be restored. Should the patient show the
slightest inclination to laugh, stop up his nose and mouth at once,
or he will soon be unable to leave off, and it will be impossible to
save him. On no account bring a patient hastily to the fire, for
the sight of fire will excite him to immoderate laughter, and his
chance of life is gone.

" In cases of nightmare, do not at once bring a light, or going
near call out loudly to the sleeper, but bite his heel or his big toe,
and gently utter his name. Also spit on his face and give him
ginger tea to drink ; he will then come round. *Or*, Blow into the
patient's ears through small tubes, pull out fourteen hairs from his
head, make them into a twist and thrust into his nose. Also, give
salt and water to drink. Where death has resulted from seeing
goblins, take the heart of a leek and push it up the patient's nostrils
—the left for a man, the right for a woman. Look along the inner
edge of the upper lips for blisters like grains of Indian corn, and
prick them with a needle."

The work concludes with an antidote against a certain dangerous poison known as *Ku*, originally discovered by a Buddhist priest and successfully administered in a great number of cases. Its ingredients, which comprise two red centipedes—one live and one roasted—must be put into a mortar and pounded up together either on the 5th of the 5th moon, the 9th of the 9th moon, or the 8th of the 12th moon, in some place quite away from women, fowls, and dogs. Pills made from the paste produced are to be swallowed one by one without mastication. The preparation of this deadly *Ku* poison is described in the last chapter but one of Section III. in the following words :—

" Take a quantity of insects of all kinds and throw them into a vessel of any kind ; cover them up, and let a year pass away before you look at them again. The insects will have killed and eaten each other until there is only one survivor, and this one is *Ku*."

In the next chapter we are informed that spinach eaten with tortoise is poison, as also is shell-fish eaten with venison ; that death frequently results from drinking pond-water which has been poisoned by snakes, from drinking water which has been used for flowers, or tea which has stood uncovered through the night, from eating the flesh of a fowl which has swallowed a centipede, and wearing clothes which have been soaked with perspiration and dried in the sun. Finally,

" A case is recorded of a man who tied his victim's hands and feet, and forced into his mouth the head of a snake, applying fire at the

same time to its tail. The snake jumped down the man's throat and passed into his stomach, but at the inquest held over the body no traces of wounds were found to which death could be attributed. Such a crime, however, may be detected by examination of the bones which, from the head downwards, will be found entirely of a bright red colour, caused by the dispersion of the blood ; and moreover, the more the bones are scraped away, the brighter in colour do they become."

It is difficult to speak of such a book as " Instructions to Coroners" with anything like becoming gravity, and yet it is one of the most widely-read and highly-esteemed works in China; so much so, that native scholars frequently throw it in the teeth of foreigners as one of their many repertories of real wonder-working science, equal to anything that comes from the West, if only foreigners would take the trouble to consult it. To satisfy our own curiosity on the subject we bought a copy and translated it from beginning to end; but our readers will perhaps be able to determine its scientific value from the few quotations given above, and agree with us that it would hardly be worth while to learn Chinese for the pleasure or profit to be derived from reading " Instructions to Coroners" in the original character.

THE extraordinary feeling of hatred and contempt evinced by the Chinese nation for missionaries of every denomination who settle in their country, naturally suggests the question whether Christianity is likely to prove a boon to China, if, indeed, it ever succeeds in taking root at all. That under the form of Roman Catholicism, it once had a chance of becoming the religion of the Empire, and that that chance was recklessly sacrificed to bigotry and intolerance, is too well known to be repeated ; but that such an opportunity will ever occur again is quite beyond the bounds, if not of possibility, at any rate of probability. Missionary prospects are anything but bright in China just now, in spite of rosily-worded "reports," and annual statistics of persons baptized. A respectable Chinaman will tell you that only thieves and bad characters who have nothing to lose avail themselves of baptism, as a means of securing "long nights of indolence and ease" in the household of some enthusiastic missionary at from four to ten dollars a month. Educated men will not tolerate missionaries in their houses, as many have found to their cost ; and the fact cannot be concealed that the foreign community

in China suffers no small inconvenience and incurs considerable danger for a cause with which a large majority of its members has no sympathy whatever. It would, however, be invidious to dwell upon the class of natives who allow themselves to be baptized and pretend to accept dogmas they most certainly do not understand, or on the mental and social calibre of numbers of those gentlemen who are sent out to convert them ; we will confine ourselves merely to considering what practical benefits Christianity would be likely to confer upon the Chinese at large. And this we may fairly do, not being of those who hold that all will be damned but the sect of that particular church to which they themselves may happen to belong; but believing that the Chinese have as good a chance as anybody else of whatever happiness may be in store for the virtuous, whether they become Christians or whether they do not.

In the course of eight years' residence in China, we have never met a drunken man in the streets. Opium-smokers we have seen in all stages of intoxication ; but no drunken brawls, no bruised and bleeding wives. Would Christianity raise the Chinese to the standard of European sobriety ? Would it bring them to renounce opium, only to replace it with gin ? Would it cause them to be more frugal, to live more economically than they do now on their bowl of rice and cabbage, moistened with a drink of tea, and perhaps supplemented with a few whiffs of the mildest possible tobacco ? Would it cause them to be more industrious than—*e.g.*, the wood-carvers of Ningpo who work

N

daily from sunrise to dusk, with two short intervals for meals ? Would it make them more filial ?—justly renowned as they are for unremitting care of aged and infirm parents. More fraternal ?—where every family is a small society, each member toiling for the common good, and being sure of food and shelter if thrown out of work or enfeebled by disease. More law-abiding ? —we appeal to any one who has lived in China, and mixed with the people. Would it make them more honest ?—when many Europeans confess that for straightforward business they would sooner deal with Chinamen than with merchants of certain Christian nationalities we shall not take upon ourselves to name. Should we not run the risk of sowing seed for future and bloody religious wars on soil where none now rage ? To teach them justice in the administration of law would be a glorious task indeed, but even that would have its dark side. Litigation would become the order of the day, and a rapacious class would spring into existence where lawyers and barristers are now totally unknown. The striking phenomenon of extreme wealth side by side with extreme poverty, might be produced in a country where absolute destitution is at present remarkably rare, and no one need actually starve ; and thus would be developed a fine field for the practice of that Christian charity which by demoralisation of the poorer classes so skilfully defeats its own end. We should rejoice if anything could make Chinamen less cruel to dumb animals, desist from carrying ducks, geese, and pigs, hanging by their legs to a pole, feed

their hungry dogs, and spare their worn-out beasts of burden. But pigeon-shooting is unknown, and gag-bearing reins have yet to be introduced into China; neither have we ever heard of a poor heathen China-man "skinning a sheep alive." (*Vide Daily Papers of July* 12, 1875.)

Last of all, it must not be forgotten that China has already four great religions flourishing in her midst. There is *Confucianism*, which, strictly speak-ing, is not a religion, but a system of self-culture with a view to the proper government of (1) one's own family and of (2) the State. It teaches man to be good, and to love virtue for its own sake, with no fear of punishment for failure, no hope of reward for success. Is it below Christianity in this?

Buddhism, Taoism, and *Mahometanism*, share the patronage of the illiterate, and serve to satisfy the natural craving in uneducated man for something supernatural in which to believe and on which to rely. The *literati* are sheer materialists : they laugh at the absurdities of Buddhism, though they sometimes condescend to practise its rites. They strongly object to the introduction of a new religion, and successfully oppose it by every means in their power. They urge, and with justice, that Confucius has laid down an admirable rule of life in harmony with their own customs, and that the conduct of those who approxi-mate to this standard would compare not unfavourably with the practice, as distinguished from the profession, of any religion in the world.

THE following inflammatory placard, which was posted up last year at a place called Lung-p'ing, near the great tea mart of Hankow, will give a faint idea of native prejudice against the propagation of Christianity in China. The original was in verse, and evidently the work of a highly-educated man :—

> Strange doctrines are speedily to be eradicated :
> The holy teaching of Confucius is now in the ascendant.
> There is but one most sacred religion :
> There can be but one Mean.
> By their great virtue Yao and Shun led the way,
> Alone able to expound the "fickle" and the "slight ; "*
> Confucius' teachings have not passed away,
> Yet working wonders in secret † has long been in vogue.
> Be earnest in practising the ordinary virtues :
> To extend filial piety, brotherly love, loyalty, and considerateness,
> is to benefit one's-self.
> Be careful in your speech,
> And marvels, feats of strength, sedition, and spirits,‡ will disap-
> pear from conversation.
> I pray you do not listen to unsubstantiated words :
> Then who will dare to deceive the age with soft-sounding
> phrases.

* The fickle nature of men's minds, and slight regard for the true doctrine.

† Forbidden by Confucius.

‡ Avoided by Confucius as topics.

Our religion is for all who choose to seek it ;
But we build no chapels to beguile the foolish.
Our true religion has existed from of old, up to the present day,
 undergoing no change.
Its true principles include in their application those of the middle
 and outside nations alike.
Great is the advantage to us !
Great is the good influence on this generation !
Of all religions the only true one,
What false doctrine can compare with it ?
The *stillness* and *cleanliness* of Buddhism,
The *abstruseness* and *hollow mockery* of Taoism—
These are but side-doors compared with ours ;
Fit to be quitted, but not to be entered.
These are but by-paths compared with ours ;
Fit to be blocked up, but not to be used.
How then about this one, stranger than Buddhist or Taoist creed ?
With its secret confusion of sexes, unutterable !
More hurtful than all the dogmas of the other two ;
Spreading far and wide the unfathomable poison of its mysteries.
Herein you must carefully discriminate,
And not receive it with belief and veneration.
 Those who now embrace Christ
Call him Lord of heaven and earth,
Worshipping him with prayer,
Deceiving and exciting the foolish,
Dishonouring the holy teaching of Confucius.
I laugh at your hero of the cross,
Who, though sacrificing his life, did not preserve his virtue
 complete.
Missions build chapels,
But the desire to do good works is not natural to them.
The method of influencing the natures of women
Is but a trick to further base ends.
They injure boys by magical arts,
And commit many atrocious crimes.
They say their religion is the only true one,
But their answers are full of prevarication.

They say their book is the Holy Book,
But the Old and New Testaments are like the songs of Wei and
 Chêng.*
As to the people who are gradually being misled,
I compassionate their ignorance ;
As to the educated who are thus deceived,
I am wroth at their want of reflection.
For these men are not of us ;
We are like the horse and the cow ; †
If you associate with them,
Who will expel these crocodiles and snakes ?
This is a secret grievance of the State,
A manifest injury to the people !
Truly it is the eye-sore of the age.
You quietly look on unconcerned !
I, musing over the present state of men's hearts,
Desire to rectify them.
Alas ! the ways of devils are full of guile !
But man's disposition is naturally pure.
How then can men willingly walk with devils ?
You, like trees and plants, without understanding,
Allow the barbarians to throw into confusion the Flowery Land.
Is it that no holy and wise men have appeared ?
Under the Chow dynasty, when the barbarians were at the
 height of their arrogance,
The hand of Confucius and Mencius was laid upon them !
Under the T'ang when Buddhism was poisoning the age,
Han and Hsi exterminated them.
Now these devils are working evil,
Troubling the villages and market-places where they live.
Surely many heroes must come forward
To crush them with the pen of Confucius.
Turn then and consider
That were it not for my class ‡
None would uphold the true religion.

* Licentious.
† The Chinese say horses prefer going against, cows with, the wind.
‡ The *literati.*

I say unto you,
And you should give heed unto me,
Believe not the nonsense of Redemption,
Believe not the trickery of the Resurrection.
Set yourselves to find out the true path,
And learn to distinguish between man and devil.
Pass not with loitering step the unknown ford,
Nor bow the knee before the vicious and the depraved.
Wait not for Heaven to exterminate them
To find out that earth has a day for their destruction.
The shapeless, voiceless imp—
Why worship him?
His supernatural, unprincipled nonsense
Should surely be discarded.
Ye who think not so,
When the devils are in your houses
They will covet your homes,
And they will take the fingers and arms of your strong ones
To make claws and teeth for imps.
They excite people at first by specious talk,
Not one jot of which is intelligible;
Then they destroy your reason,
Making you wander far from the truth.
You throw over ancestral worship to enjoy none yourselves;
Your wives and children suffer pollution,
And you are pointed at with the finger.
Thus heedlessly you injure eternal principles,
Embracing filth and treasuring corruption,
To your endless shame
And to your everlasting misfortune.
Finally, if in life your heads escape the axe,
There will await you the excessive injury of the shroud.*
Judging by the crimes of your lives,
Your corpses will be cast to scorpions and snakes.
The devils introduce this doctrine,

* Missionaries are said to keep the corpses of converts concealed from public view between death and interment, that the absence of the dead man's eyes may not be detected.

Which grows like plants from seeds ;
Some one must arise to punish them,
And destroy their religion root and branch.
Hasten, all of you, to repent,
And walk in the way of righteousness;
We truly pity you.
A warning notice to discard false doctrines !

CONCLUSION.

"SURELY it is manifest enough that by selecting the evidence, any society may be relatively blackened, and any other society relatively whitened."* We hope that no such principle of selection can be traced in the preceding pages. Irritation against traducers of China and her morality † may have occasionally tinged our views with a somewhat rosy hue; but we have all along felt the danger of this bias, and have endeavoured to guard against it. We have no wish to exalt China at the expense of European civilisation, but we cannot blind ourselves to the fact that her vices have been exaggerated, and her virtues overlooked. Only the bigoted or ignorant could condemn with sweeping assertions of immorality a nation of many millions absolutely free, as the Chinese are, from one such vice as drunkenness; in whose cities may be seen—what all our legislative and executive skill cannot secure— streets quiet and deserted after nine or ten o'clock at

* Spencer's Sociology : The Bias of Patriotism.

† " The miseries and horrors (?) which are now destroying (?) the Chinese Empire are the direct and organic results of the moral profligacy of its inhabitants."—*Froude's Short Studies on Great Subjects.*

night. Add to this industry, frugality, patriotism,*
and a boundless respect for the majesty of office:
it then only remains for us to acknowledge that
China is after all "a nation of much talent, and, in
some respects, even wisdom." †

* "Every patriotic Chinese—and there are millions of such."—*Dr
Legge to London and China Telegraph, July 5, 1875.*
† Mill's Essay on Liberty.

INDEX.

PRINTED BY BALLANTYNE AND COMPANY
EDINBURGH AND LONDON

www.ingramcontent.com/pod-product-compliance
Lightning Source LLC
Chambersburg PA
CBHW030828270326
41928CB00007B/951